Watercolor Basics: Color

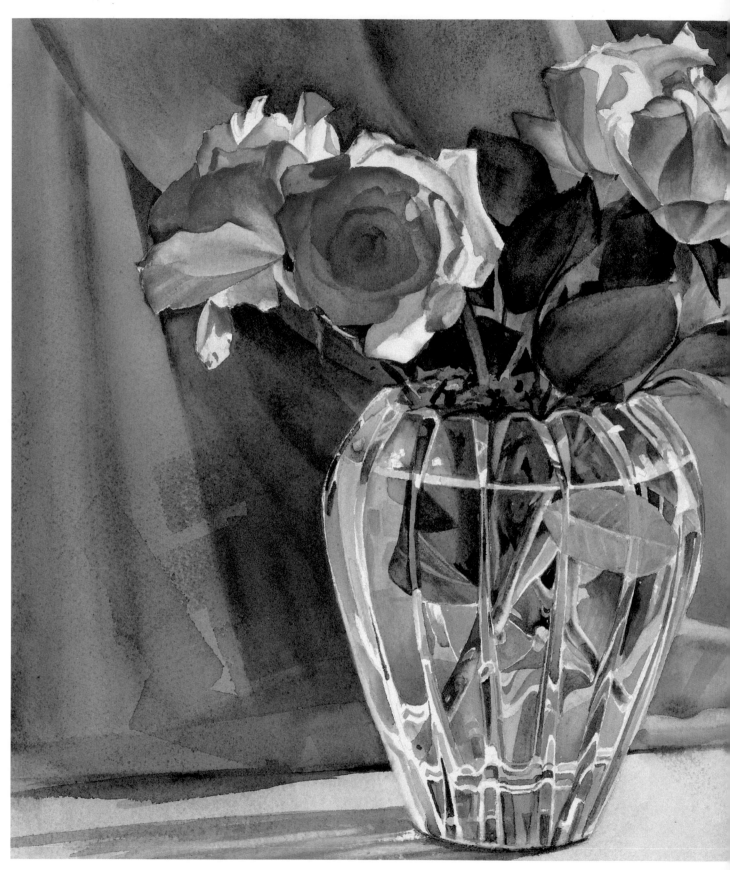

Four Roses
13½″ × 16″ (34.3cm × 40.6cm)

Watercolor Basics: Color

JAN KUNZ

NORTH LIGHT BOOKS
CINCINNATI, OHIO

ABOUT THE AUTHOR

Jan received her art education in Southern California where she attended the University of California at Los Angeles. Any leisure time she could find during the busy years of raising a family and juggling a career as art director for a large advertising firm was spent painting in watercolor. She studied privately with such distinguished painters as James Boren, Rex Brandt, Lester M. Bonar and James Cooper Wright. In 1978 she began to devote herself full time to her new career.

Jan is a signature member of the American Academy of Women Artists and is the author of several other North Light Books, including *Painting Watercolor Portraits That Glow* (1989), *Painting Watercolor Florals That Glow* (1993), *Watercolor Techniques* (1994), and *Painting Beautiful Watercolors From Photographs* (1998).

Watercolor Basics: Color. Copyright © 1999 by Jan Kunz. Manufactured in China. All rights reserved. No part of this book may be reproduced in any form or by any electronic or mechanical means including information storage and retrieval systems without permission in writing from the publisher, except by a reviewer, who may quote brief passages in a review. Published by North Light Books, an imprint of F&W Publications, Inc., 1507 Dana Avenue, Cincinnati, Ohio 45207. (800) 289-0963. First edition.

Other fine North Light Books are available from your local bookstore, art supply store or direct from the publisher.

03 02 01 00 5 4 3 2

Library of Congress Cataloging-in-Publication Data

Kunz, Jan.
 Watercolor basics: color / Jan Kunz.—1st ed.
 p. cm.— (Watercolor basics)
 Includes index.
 ISBN 0-89134-886-7 (pbk. : alk. paper)
 1. Color in art. 2. Watercolor painting—Technique. I. Title. II. Series.
ND2422.K87 1999
751.42'2—dc21 98-31183
 CIP

Edited by Joyce Dolan
Production coordinated by Kristen Heller
Production edited by Michelle Kramer
Designed by Angela Lennert Wilcox

DEDICATION

This book is dedicated to Greg, whose strength and love are a constant source of comfort and inspiration.

ACKNOWLEDGMENTS

I'm indebted to all the people who have helped make this book possible. Thanks to my husband, Bill, who never complained about the long hours and not only helped proofread the text, but kept the home front running smoothly. Thanks to editor Joyce Dolan who was responsible for organizing the book and keeping me on track and to all the other people at North Light who convert this jumble of art and notes into a presentable final product.

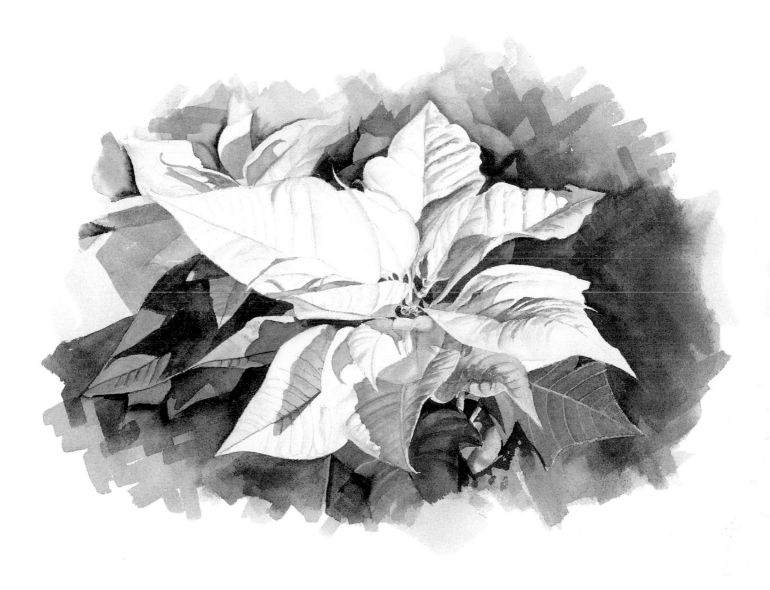

Poinsettia
12″×17″ (30.5cm×43.2cm)

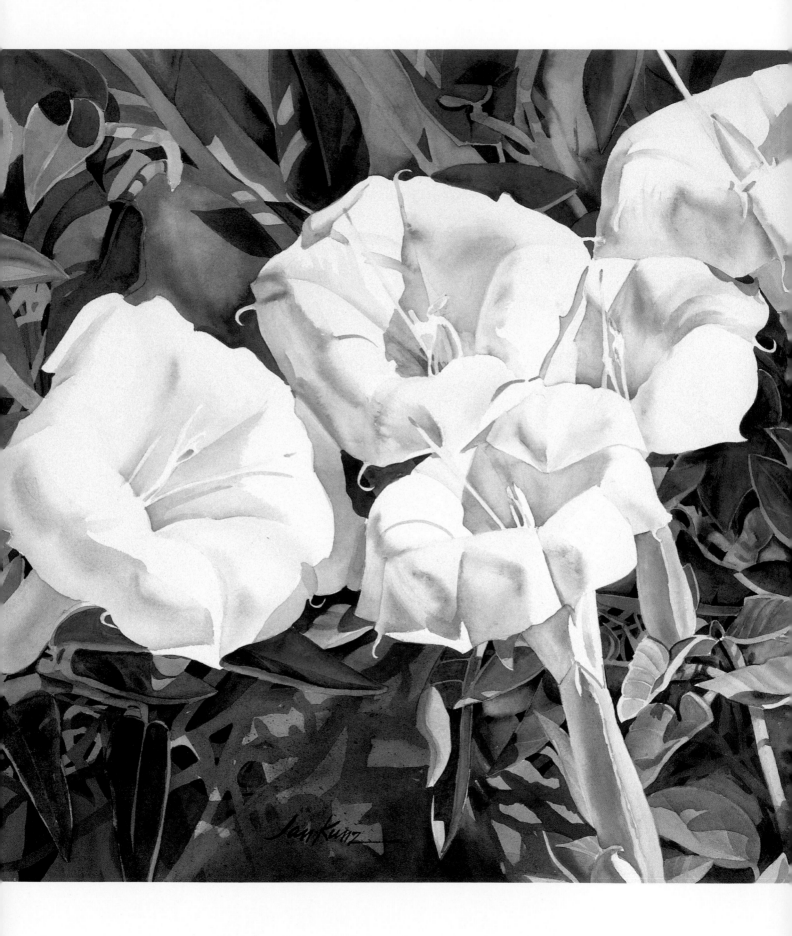

CONTENTS

INTRODUCTION 8
Includes all the materials you'll need to get started.

1 WHAT IS COLOR? 12
*Learn about the three dimensions of color—hue, value and
intensity—through eight step-by-step painting projects.*

2 PHYSICAL PROPERTIES OF
WATERCOLOR PIGMENTS 54
*Discover what to expect of your watercolor pigments. Learn
about opaque and transparent colors, high and low intensity
colors and how to create brilliant dark values.*

3 WHAT COLOR IS IT? 66
*See color with an artist's eye. Step-by-step painting projects show
you how to paint objects in sunlight, how to add brilliant color
to dull objects and how to paint the illusion of sunlight.*

4 PUT IT ALL TOGETHER 80
*Use all you've learned to paint these eight beautiful step-by-step
projects.*

Conclusion 124
Index 126

White Glory
22″ × 30″ (55.9cm × 76.2cm)

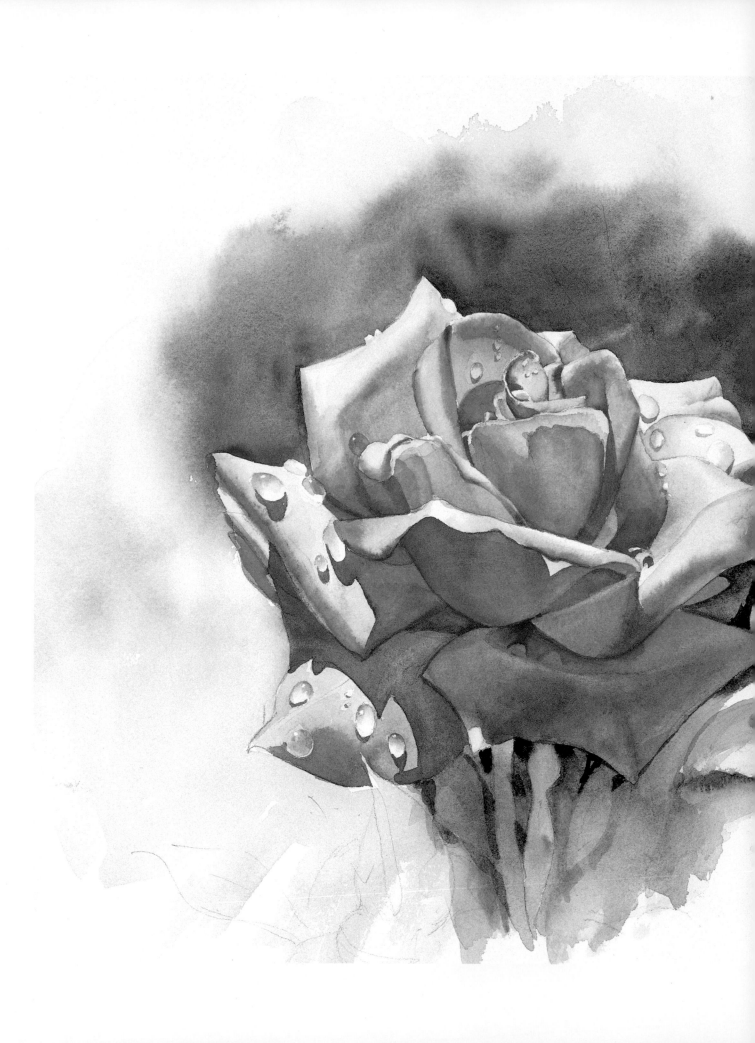

INTRODUCTION

You'll learn color principles in this book that are applicable to all mediums, but even better, you may also learn to see like an artist. That may sound a bit pompous, but there's a big difference between "looking" and "seeing." By learning where to look and what to expect, you'll see color as never before.

Learning to handle the watercolor medium takes time. Every watercolorist collects a considerable number of "learning experiences" before mastering the medium. The truth is, you learn to paint by painting. I hope you'll paint every exercise along with me and have fun doing it. Don't worry if the pages get splattered—it's for a good cause! If some of the exercises seem boring, remember they're here to help you become thoroughly familiar with some aspect of color. Once you begin to paint you'll recognize how important these studies are.

Morning Dew
15″ diameter (38.1cm)

Getting Started

Here's a list of materials you'll need to get started. If you already have some supplies, use what you have; you can always add to them when necessary.

Paint

I suggest you buy watercolors in tubes. Daniel Smith, Holbein, Schmincke and Winsor & Newton all manufacture fine watercolor pigments. Grumbacher Academy is a good student-grade paint, but ask your dealer if you aren't sure which brand to buy.

These are the colors I used to complete the projects in this book. I've marked with an asterisk the ones you'll need right away, but you'll want to add the others as we progress. Payne's Gray is used for value studies but it doesn't have a permanent place on my palette.

Cadmium Yellow*
New Gamboge
Cadmium Orange*
Cadmium Red*
Rose Madder Genuine
Permanent Alizarin Crimson
Burnt Sienna
Raw Sienna
Burnt Umber
Cobalt Blue*
French Ultramarine Blue
Phthalo Blue or Winsor Blue (Green Shade)
Permanent Sap Green
Phthalo Green or Winsor Green (Blue Shade)
Hooker's Green*
Payne's Gray*

Watercolor pigments are available in 5ml. tubes and the 15ml. size shown here.

Brushes

You'll find use for a no. 8 and no.12 round brush and a 1-inch (2.5cm) aquarelle. The aquarelle is a large flat brush for large areas, and the round ones are for fill-in and detail. There are so many good synthetic brushes on the market today, you don't have to mortgage the farm to own a good brush. Look for one that holds a considerable quantity of water and springs back to a point after you use it. A tired brush will only cause you grief.

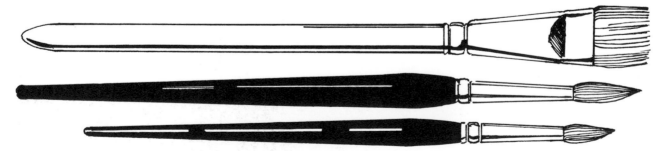

Round water color brushes should hold plenty of water and come to a fine point. Larger flat brushes are especially useful to fill in large areas.

Paper

It's important to use good paper for these projects. You'll be referring to them often, and poor paper can make your work more difficult. Arches 140-lb. (300gsm) cold-press watercolor paper or an equivalent is a good choice.

Palette

There's a wide choice of palette styles available. Most watercolor palettes are made of white plastic. Select one with several deep paint wells and plenty of room for mixing. I know several artists who prefer to use ice cube trays for paint wells and a butcher tray or a platter for mixing color.

Water Container

I recommend a large water container. Cut the top off a gallon plastic jug, or use an empty plastic ice cream container. The larger the container, the longer the water will stay clean. Even at that, you'll want to change the water frequently.

Paint Rag

Old bar towels make great paint rags. These are terry-cloth towels, about fourteen to sixteen inches (35.6cm to 40.6cm) square, that restaurants and bars use to pick up spills. Any old towel or absorbent fabric will serve as well. I keep my paint rags clean by laundering them in the washing machine.

Brush Holder

It's a good habit to have your brushes on your desk where you can easily reach them. When I'm painting on location I use a large plastic cup for this purpose. In the studio I use a carousel, but they both work equally well.

Facial Tissue

You will be glad you have facial tissue at hand. It's handy for wiping out your palette and soaking up spills.

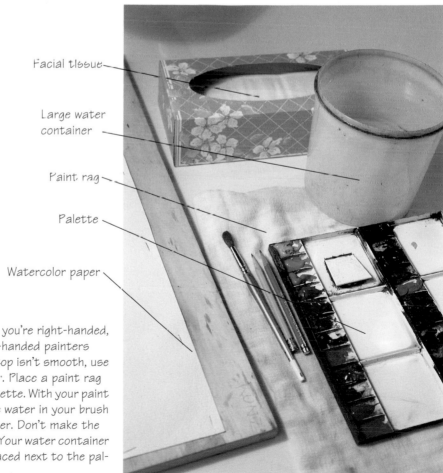

Facial tissue

Large water container

Paint rag

Palette

Watercolor paper

PAINTING AREA

Here's how to set up your work area. If you're right-handed, put your tools on your right side. Left-handed painters should reverse the setup. If your tabletop isn't smooth, use a drawing board to support your paper. Place a paint rag between the drawing board and your palette. With your paint rag in this position you can adjust the water in your brush before approaching the watercolor paper. Don't make the mistake of holding onto your paint rag. Your water container should be at least a quart size and placed next to the palette, above the rag.

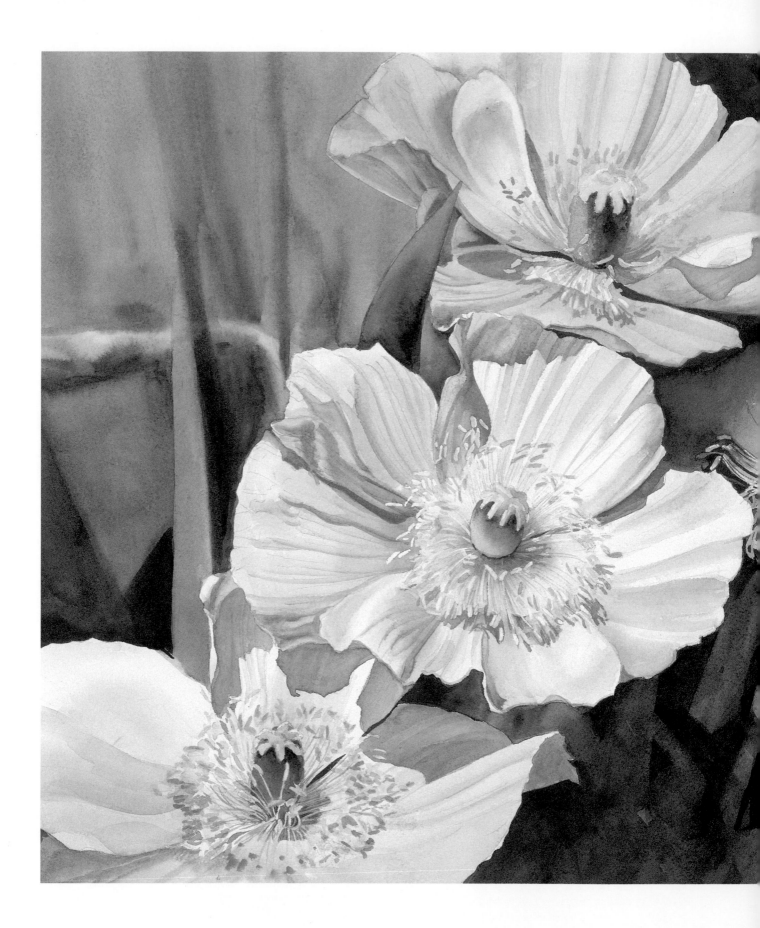

WHAT IS COLOR?

Color is a sensation we experience when our eyes are struck by light waves of varying lengths. Like music, color is a vibratory phenomenon. Violet, at one end of the spectrum, has a very short wavelength (number of vibrations per second); in musical terms it might be compared to a high screech. Red, with the longest wavelength, is analogous to a deep note on a bassoon.

Sunlight, or white light, contains a balanced mixture of all wavelengths of the visible spectrum. Isaac Newton first discovered the nature of light when he used a prism to divide different groups of color waves. You see this same phenomenon in the colors of a rainbow or in streaks of color glinting through crystal.

Sun Worshippers
22″×30″ (55.9cm×76.2cm)

Pigment

Colored objects contain *pigment* which absorbs certain rays of color and reflects others. A banana is yellow because pigment in the banana's skin reflects yellow rays and absorbs all the other colors. A red apple reflects only red rays and absorbs all the others, and so on.

Our paints are made from minerals and animal products which are especially rich in pigments. Manufacturers carefully select and purify these materials to ensure their permanence. French Ultramarine Blue was originally made by grinding lapis lazuli, a semiprecious stone, and then purifying it. Today French Ultramarine Blue is produced synthetically. Permanent Sap Green is made from the juice of iris flowers, and Sepia, a dark brown-black color, is made from the ink sacs of cuttlefish. Watercolor pigments have remained brilliant for centuries. When we paint we use purified pigments that reflect the color waves we want to use and absorb all the others.

Organizing Color

Centuries ago, artists didn't have an accurate way of describing color. Some primitive people had no names for color in their language, and even though references to the sky or heaven appear more than four hundred times in the Bible, the word "blue" appears nowhere. In the middle 1800s, an observant scientist discovered that every color has three different qualities: hue, value and intensity. In 1912, Albert H. Munsell came up with a system to precisely define color qualities and measure their intervals. Today Munsell's theory is used worldwide.

Happily for us, it's not necessary to memorize a complicated system of letters and numbers. As artists, our concerns are learning to understand and control differences in hue, value and intensity.

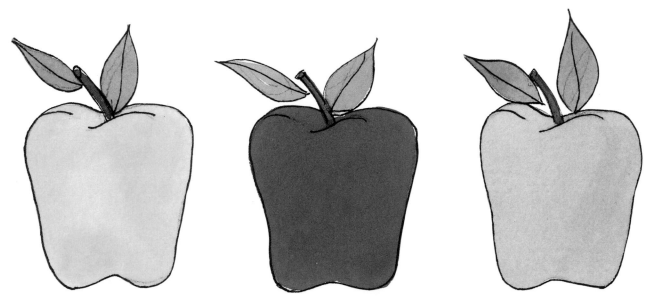

The yellow apple appears yellow because it contains pigments that reflect yellow light and absorb all the rest. The red and green apple reflect those two colors and so on.

Hue

Hue is the term used to name a color. It has nothing to do with whether the color is light or dark, strong or weak. Yellow, red and blue are three different hues. We can also identify variations of hues within a single basic color, such as yellow-green or yellow-orange.

A good way to understand how colors relate to one another is to make a color wheel. Every hue has a special place on the color wheel. Hues located close to one another are harmonious because they each contain some of the same color. Hues separated from one another are less closely related, and those located on opposite sides of the color wheel have nothing in common. When colors opposite one another are mixed together, they form a neutral gray.

The primary colors are red, yellow and blue. We call these *primary hues* because they cannot be made from the combination of any other pigments. The secondary colors are orange, mixed from red and yellow; green, mixed from blue and yellow; and purple, made by mixing blue and red. All of the other colors are combinations of the primary and secondary colors.

On the next page is a project to make a color wheel.

Reasons to Make a Color Wheel

1. Familiarize yourself with the mechanical layout of the color wheel.
2. Gain a clear understanding of how hues on the color wheel relate to pigments on your palette.
3. Learn how to mix hues you don't have.
4. Locate and understand the concept of complementary colors.
5. Gain practice in brush control.

Project 1: Make a Color Wheel

Draw your own wheel, or trace the one you see here. The wheel consists of twelve equal spaces, one directly at the top and one at the bottom. Make your drawing on good watercolor paper. You'll want to refer to this wheel often, so be aware that the paper you use greatly affects the color and quality of your work.

Tips

1. Be sure the paper is dry before painting any section. This prevents colors from running together. Use a blow-dryer to speed up drying, but hold it back far enough so the surface dries evenly.
2. Use just enough water so the pigment flows on smoothly and is not pasty.
3. If necessary, move your paper around for easy access to the areas you are painting.

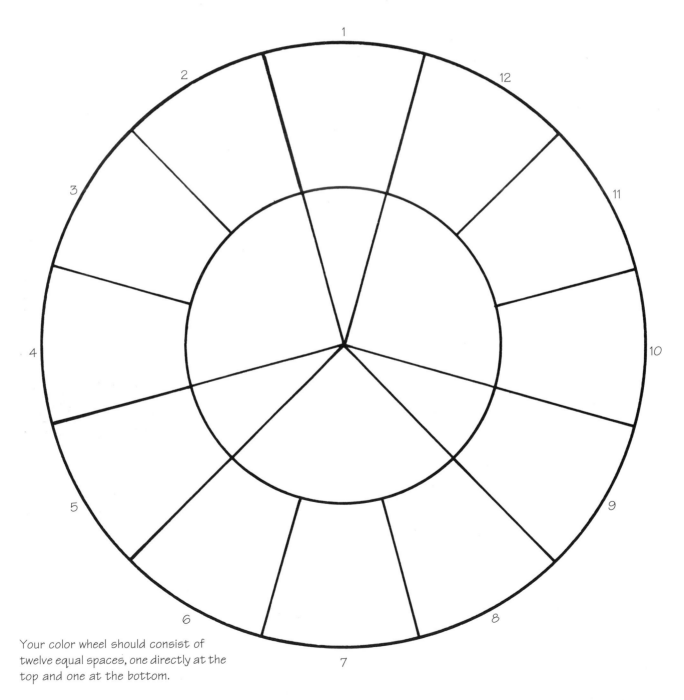

Your color wheel should consist of twelve equal spaces, one directly at the top and one at the bottom.

PRIMARY COLORS

Use a clean brush and clear water to thoroughly dissolve Cadmium Yellow, then paint the top wedge shape. Be careful to stay inside the lines, and fill in the area until it is at its most brilliant.

Next, leave three spaces blank, and put Cadmium Red in the fourth space on the left. Finally, paint Cobalt Blue in the fourth space down on the right side of the color wheel.

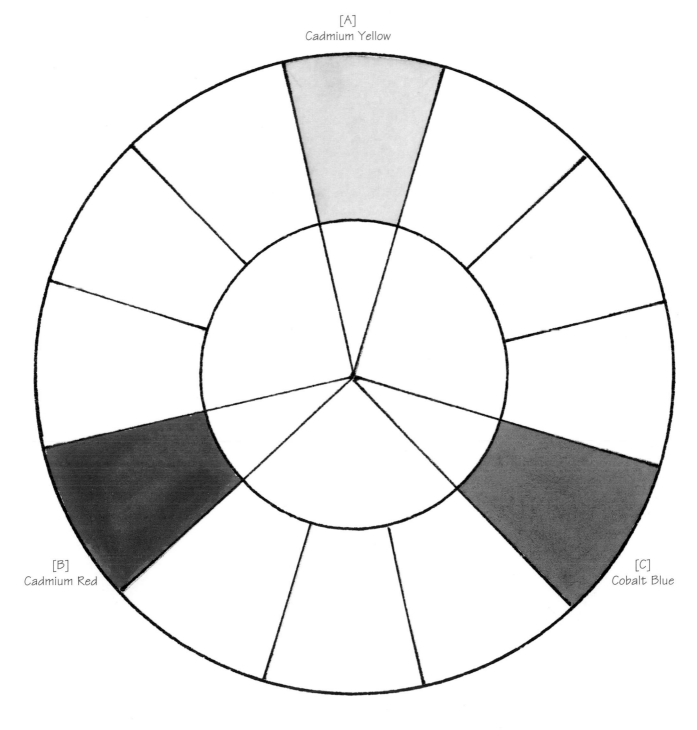

[A]
Cadmium Yellow

[B]
Cadmium Red

[C]
Cobalt Blue

Primary Colors

SECONDARY COLORS

Orange

Orange is the combination of yellow and red. It belongs in the center space between these two colors, leaving a space on either side. You can create orange by painting Cadmium Yellow into the space and adding Cadmium Red. Mixing on the paper is one of the most important practices in watercolor painting because it gives the most brilliant results.

Green

There are two choices for the space between yellow and blue. Paint a small square of Cobalt Blue on a scrap of watercolor paper. Before it dries add Cadmium Yellow, and study the result. You'll notice the color is rather gray, so instead of mixing our own color let's use Hooker's Green to fill this space. Hooker's Green is brilliant and capable of producing dark values.

Violet

The last secondary color is violet. It's a combination of blue and red and belongs in the center position at the bottom of the color wheel. This time, try painting Cadmium Red onto a scrap of watercolor paper; then add Cobalt Blue. Try the same experiment using French Ultramarine Blue and Permanent Alizarin Crimson (you can begin with either one). I think you'll agree the last combination results in a more beautiful violet. Dry the colors thoroughly.

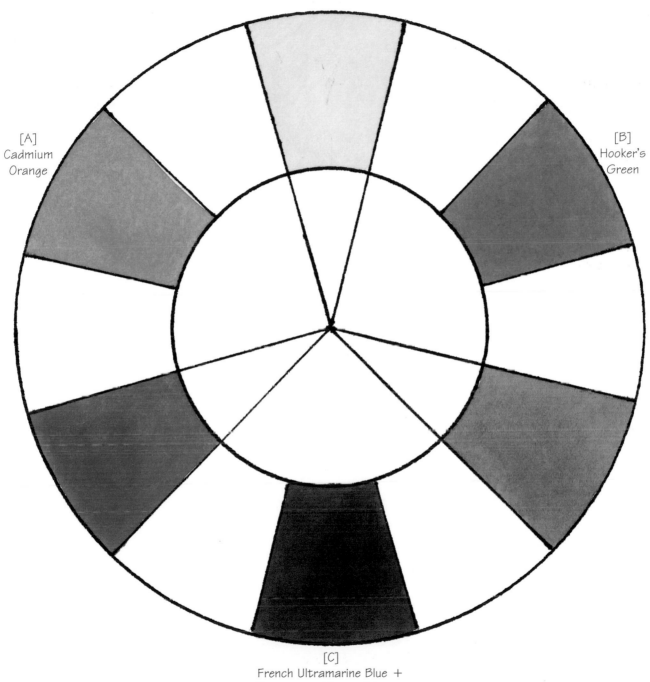

[A]
Cadmium
Orange

[B]
Hooker's
Green

[C]
French Ultramarine Blue +
Permanent Alizarin Crimson
(half-and-half)

Secondary Colors

TERTIARY COLORS

Tertiary colors are made by mixing a secondary color with a primary color. These colors are next to each other on the color wheel and are closely related. They are called *analogous colors*.

Yellow-Orange
In the space between yellow and orange, paint Cadmium Orange onto the paper; then add Cadmium Yellow. Keep adjusting the colors one at a time until you arrive at a mixture halfway between yellow and orange.

Orange-Red
After that section dries, use the same method to fill in the space between Cadmium Orange and Cadmium Red using a combination of these two colors.

Yellow-Green
Now let's go to the right side of the yellow space and mix yellow-green. Put Cadmium Yellow onto the paper and add Hooker's Green. The yellow-green should be halfway between the two adjacent colors.

Blue-Green
Blue-green lies between green and blue. This time the color should be more toward blue. Paint Cobalt Blue on the paper and add Hooker's Green.

Red and Blue-Violet
Use Permanent Alizarin Crimson mixed with the violet to fill the space between Cadmium Red and violet. Violet is a mixture of Permanent Alizarin Crimson and French Ultramarine Blue, so let's use the same two pigments to mix red-violet. Paint Permanent Alizarin Crimson on the paper, and add a small quantity of French Ultramarine Blue. Fill in the space on the other side of violet with blue-violet, made by painting French Ultramarine Blue on the paper and adding a small quantity of Permanent Alizarin Crimson.

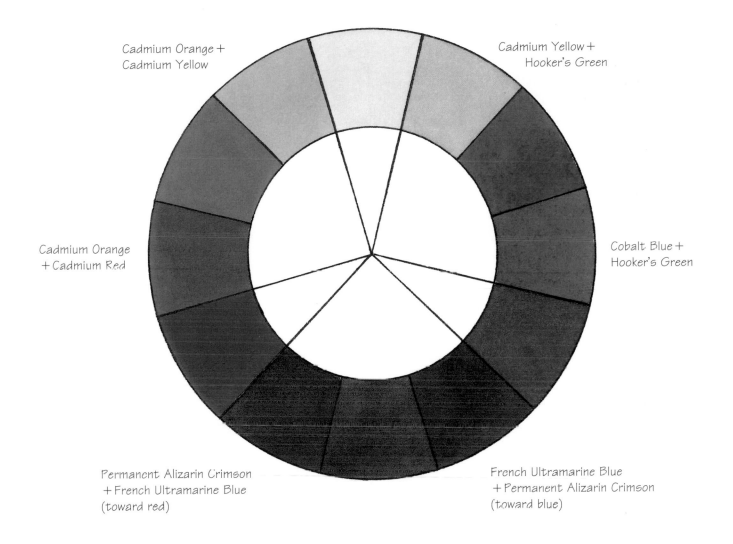

Cadmium Orange +
Cadmium Yellow

Cadmium Yellow +
Hooker's Green

Cadmium Orange
+ Cadmium Red

Cobalt Blue +
Hooker's Green

Permanent Alizarin Crimson
+ French Ultramarine Blue
(toward red)

French Ultramarine Blue
+ Permanent Alizarin Crimson
(toward blue)

Tertiary colors complete the color wheel. When your color
wheel is finished it should look like this. The color wheel is
an important tool, and we'll be using it a great deal.

Warm and Cool Colors

When artists speak of warm and cool colors, they are talking about qualities of hue. We associate red, orange and yellow with fire and warmth; ice has a bluish cast, and cold water can be green or blue. These associations account for our emotional responses to all colors.

Colors between these warm and cool extremes seem neither very warm nor very cool, and the temperature differences become subtle. We sense that a green hue appearing close to yellow is warmer than green that seems more toward blue. So we speak of warm greens and cool greens. Generally, any hue is warmed by the addition of yellow and cooled by the addition of blue.

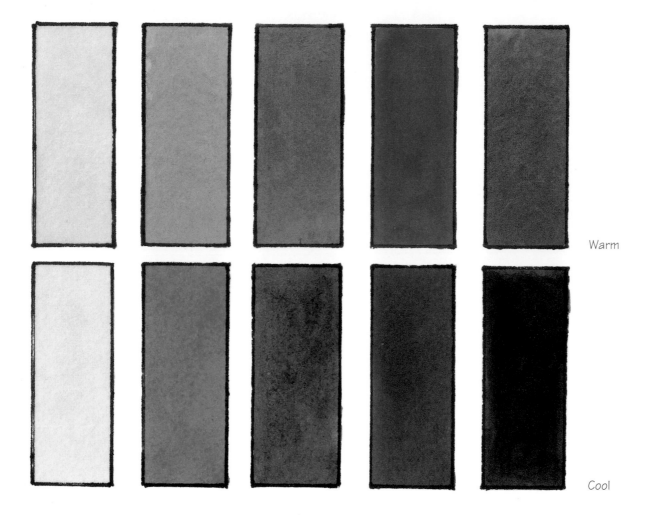

Warm

Cool

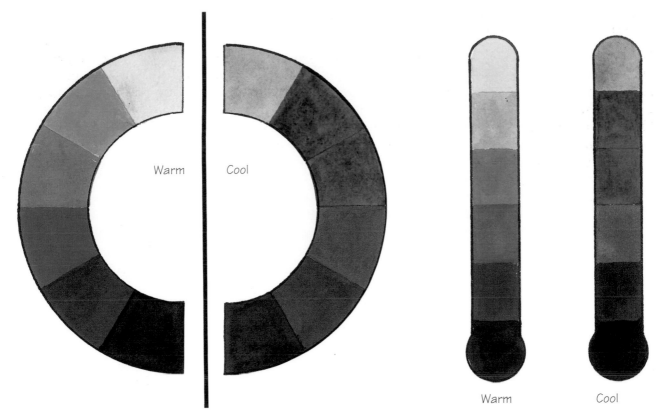

Warm Cool

Warm Cool

If you divide the color wheel in half between yellow and yellow-green at the top and between red-violet and violet at the bottom, you'll see the hues on the left side are warmer in color temperature than those on the right. Also notice that colors on either side become cooler as they approach the bottom of the wheel.

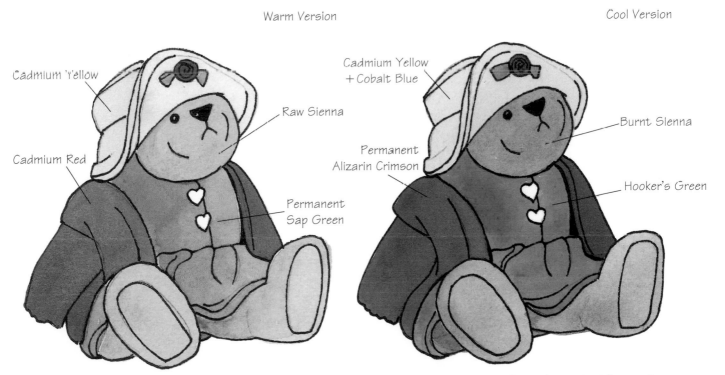

Warm Version Cool Version

Cadmium Yellow

Cadmium Yellow + Cobalt Blue

Raw Sienna

Burnt Sienna

Cadmium Red

Permanent Alizarin Crimson

Permanent Sap Green

Hooker's Green

It's possible to buy warm and cool versions of the same hue. Cadmium Red is warmer in color temperature than Permanent Alizarin Crimson. Permanent Sap Green is warmer than Hooker's Green, and Winsor Green (Blue Shade) is cooler still. Here's a warm and cool version of the same painting.

Project 2: Set Up Your Palette

Warm Together, Cool Together

Now that you understand how colors relate to one another, it's time to set up your palette. Group warm colors in one section and cool ones in another the way they appear on the color wheel. Notice I've placed the umbers and siennas on the warm side of the palette. Raw Sienna is a gray-yellow, and Burnt Sienna is a gray-orange. These pigments, along with Raw Umber and Burnt Umber, are known as earth colors.

Fill Wells

Squeeze out about a half-inch (1.3cm) of pigment, and press it down into the wells. This keeps the paint from drying out rapidly. If your pigment gets too hard to use, lift it out with a palette knife and turn it over. Discard the pigment if it's hard all the way through. A piece of plastic wrap over the top will keep your paints moist.

Reserve Empty Spaces

Two empty spaces on my palette are reserved for pigments that I use but are not required for the projects in this book. They are Raw Umber and Permanent Sap Green. It's always a good idea to have empty wells for special colors.

You Can Always Change

You may want to change the arrangement of the pigments on your palette after you've painted for a while. Your choice of palette may also change, so don't worry if your palette isn't shaped like the one in the diagram. It's far more important that you learn to recognize each pigment and remember its position on your palette.

Tip

It's important to clean your palette and pigments frequently. Color loses brilliance as it's transferred from pigment to pigment during the painting process. I take my palette to the sink and run a gentle stream of cool water directly onto the pigments, and with a small brush, gently remove any color that doesn't belong. I give my palette a quick shake and wipe it dry. Little color is lost and what is left is brilliant and ready for use.

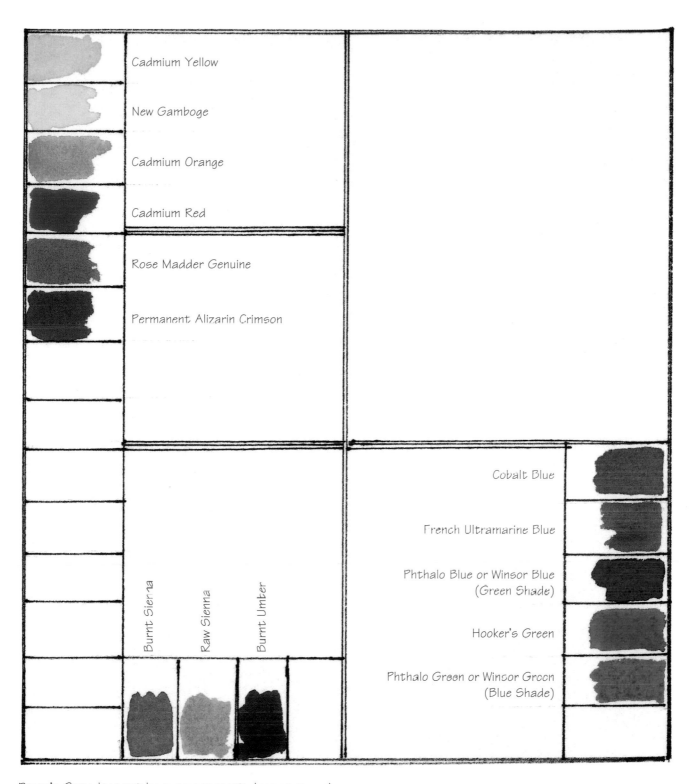

Cadmium Yellow

New Gamboge

Cadmium Orange

Cadmium Red

Rose Madder Genuine

Permanent Alizarin Crimson

Cobalt Blue

French Ultramarine Blue

Phthalo Blue or Winsor Blue
(Green Shade)

Hooker's Green

Phthalo Green or Winsor Green
(Blue Shade)

Burnt Sienna

Raw Sienna

Burnt Umber

Payne's Gray does not have a permanent place on my pal-
ette, but it is a useful hue for making value studies.

Value

The word *value* refers only to the lightness or darkness of a color. For an artist, value is by far the most important dimension of color. It's impossible to overemphasize this simple fact. I believe that once you understand value, you're three-quarters of the way to becoming a good painter. Mistakes made in hue or intensity are far less serious than errors in value.

Value Relationships

Keep in mind that whether you are outdoors or in the studio, the same value relationships that exist on one object will be seen on all other objects. This rule only fails if there are mirrorlike reflections or reflected light on the shadow side. But for now, it's better to maintain consistency rather than interpret slight differences in shading. All things being equal, the cast shadow is slightly darker than the shaded side.

Sunlit and Shadow Sides

There's another value rule so unchanging that it can almost be called a law of light: When a white box is held against the sky, the side in direct sunlight is lighter than the blue sky, and the shaded side is darker than the sky. If you intend to paint a house or any architectural structure, it's important to establish the value relationship between the sunlit and the shadow side. Once this is done, it's the key to the other value relationships.

Value Scale

It's obvious we need some means of measurement in order to arrive at consistent value relationships in our paintings. This isn't as difficult as you may think. The average human eye sees about eleven distinct variations in value, including black and white. We can construct a value scale or chart with off-white (the value of our paper) at 1 and black at value 10. By comparing the values in our paintings with this chart we can ensure consistent value relationships. I consider my value scale as important as my brushes!

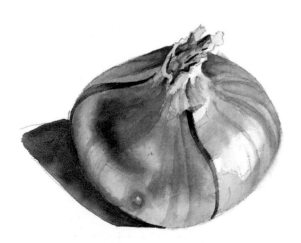 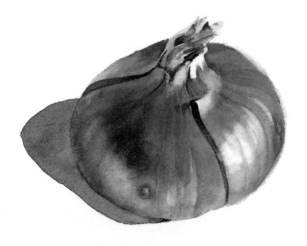

These onions demonstrate what is meant by value. The onion on the left is colorless and contains only values. The brown onion on the right contains all the properties of color: hue, value and intensity.

Project 3: Make a Value Scale

Paint Graded-Value Strips

You'll need several scraps of watercolor paper for this project. Use Payne's Gray or black pigment to paint the first piece of paper as dark as you can make it. Add water to the pigment and paint another scrap a bit lighter. Continue this process making each swatch of gray lighter and lighter until the last scrap of paper is barely tinted. Be sure the paint is dry before you make your selections because watercolor pigments dry lighter than they first appear. You may need to add more color or paint new pieces. Don't be satisfied until you have evenly graded values of gray.

Assemble the Strips

Trim your selections and mount them on a stout piece of card or hinge them at the top so they fan out and the values flow smoothly from light to dark. Mark each strip with the proper number starting with 1 for the lightest value and ending with black as value 10.

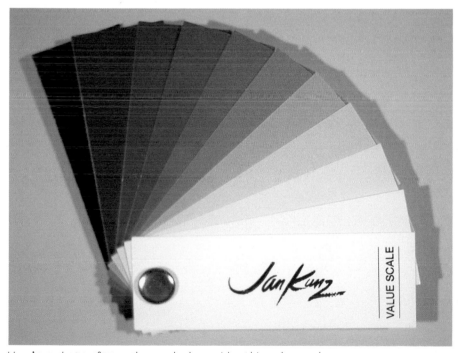

Here's a photo of my value scale. I consider this value scale as important a tool as my brushes.

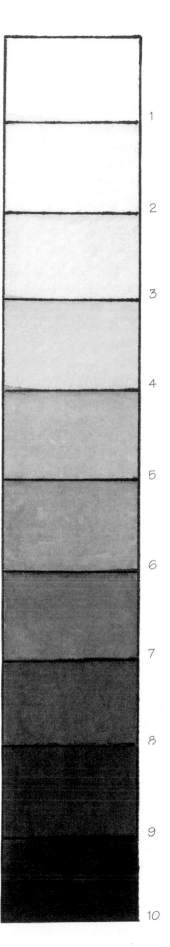

Value Scale

Determine the Value of a Hue

Now it's time to relate the hues on the color wheel to your value scale. Squint your eyes until they are almost closed, then move your value scale around the color wheel until you find a place where it's almost impossible to distinguish between the color and the gray scale. Mark that color with the number on your value scale to identify the darkest value of that particular pigment. Even though some colors such as yellow and orange are at their most intense, they're very light in value. We speak of these colors as having a short value range. On the other hand, Alizarin Crimson has a long value range. Keep practicing until you can easily determine the value of a hue. If you're having trouble, it's probably because you're not squinting hard enough.

VALUE RANGE
Value range refers to the number of values we can mix between the darkest value, straight from the tube, and the lightest value when mixed with water. Notice that the color becomes more intense as the value increases.

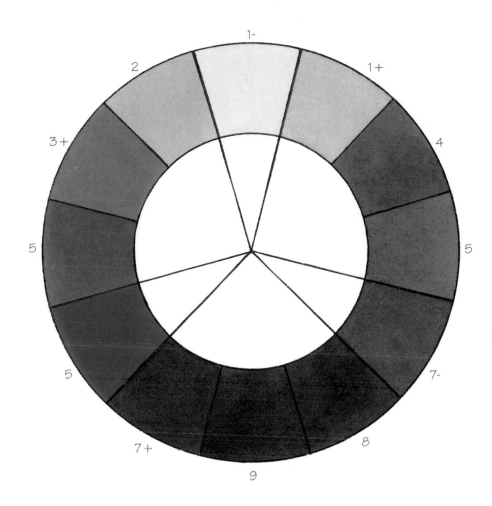

Don't worry if the value numbers on your color wheel aren't the same as mine. The pigment brand and the amount of water used makes a difference. The point is, you'll have a starting place to judge the values of the pigments in your palette and on your paintings.

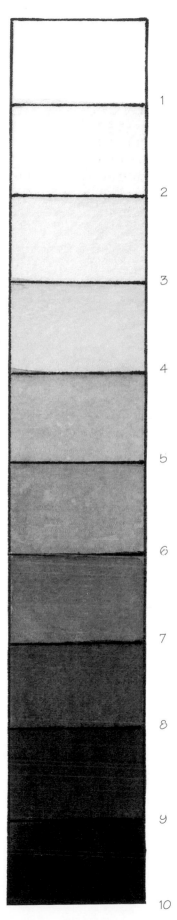

Value Scale

Project 4: Paint a Scene Using the 40-Percent Value Rule

The 40-Percent Rule

Years ago, landscape artists discovered that the shadow side of objects in sunlight is a full 40 percent darker than the sunlit side. Since our value scale is divided into ten shades of gray, it is only necessary to count up or down four values, or 40 percent, to arrive at a nearly correct value difference.

I sketched these adobe buildings at the Pueblo de Taos in New Mexico. Even using only shades of gray, we can suggest the illusion of sunlight.

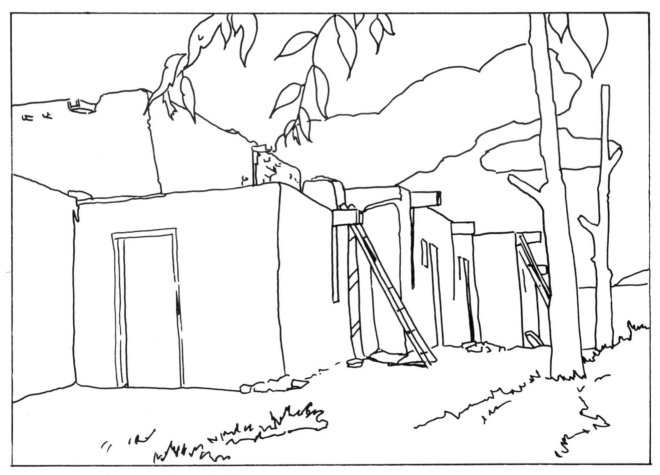

Sketch or trace the outline of these buildings onto your watercolor paper.

Step 1
Mix a large puddle of Payne's Gray, keeping the value light, somewhere around value 2. Test the value on a piece of scrap paper before you begin. Paint everything except the clouds. Dry the paper thoroughly.

Step 2
Darken the puddle to a value 4. Test first to make sure you've arrived at value 4, then paint the buildings, foreground and trees.

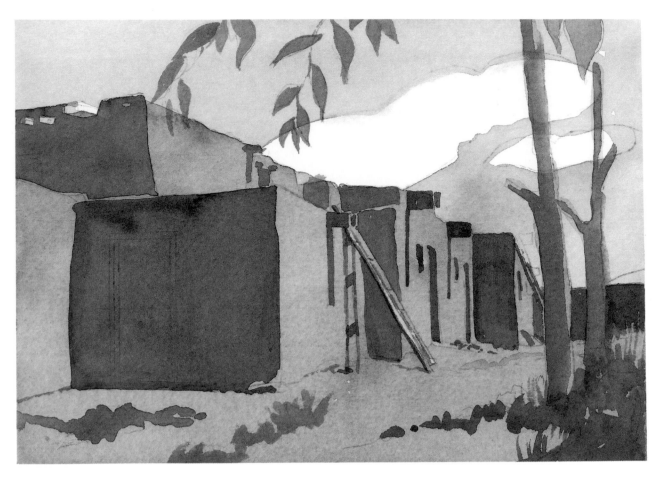

Step 3

To observe the 40-percent rule, paint the shadow side of these buildings value 8. Once again, make a sample swatch, and test for the value after the color has dried. Then paint the shadow sides of the buildings, cast shadows and foliage. Dry.

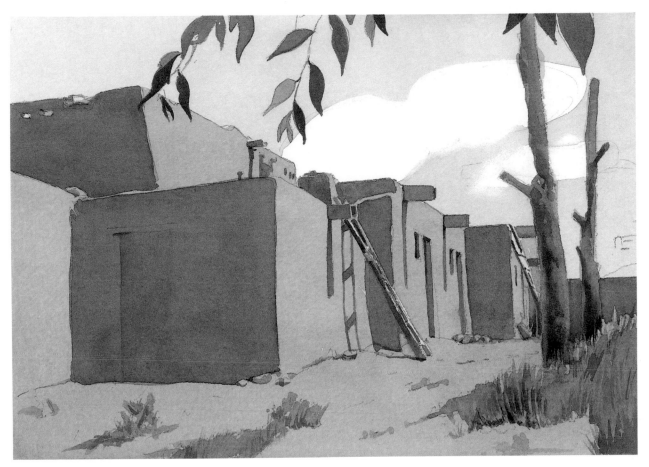

Step 4

Finish your painting by adding a few very dark values. Don't overdo this step; very dark values are for accents and interest. Many artists make a value sketch such as this to study the dark and light patterns of their paintings.

Project 5: Use Hue and Value to Paint a Scene

Now let's see how values on your gray scale relate to colors on your palette. Copy the drawing on page 30 onto a fresh piece of watercolor paper. We'll paint this same scene using four colors: Cobalt Blue, Burnt Sienna, Burnt Umber and Permanent Alizarin Crimson. To be sure the value is correct, make a test swatch before applying any color. Let it dry. Squint your eyes, and compare the color with your value scale. This is the same method you used to determine the values of the hues on your color wheel.

Tip
Anytime you want to soften an edge, remove most of the moisture from your brush. Work from the dry side and run the brush along the edge you want to soften.

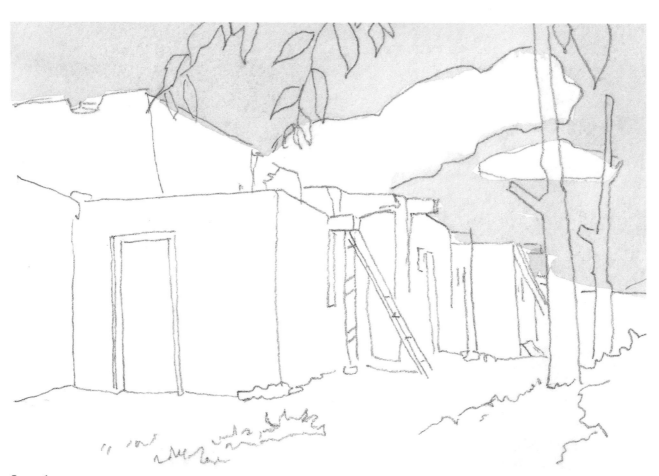

Step 1
After you have traced the drawing onto your watercolor paper, use Cobalt Blue to paint the sky. Wipe your brush dry and soften the edges of the cloud. The sky should be about value 2.

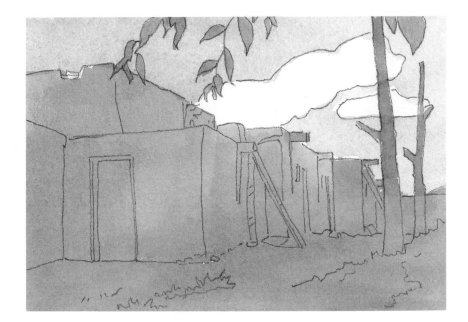

Step 2
Dilute Burnt Sienna with water until your mixture is at value 4, and check it on a test swatch. Paint everything except the sky with this mixture.

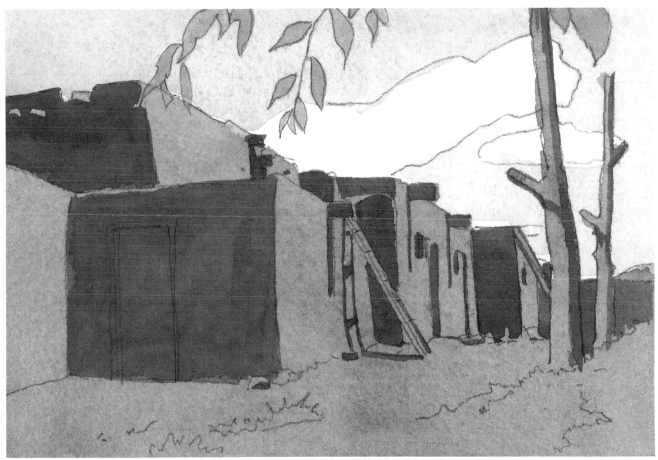

Step 3
Use a mixture of Burnt Sienna and Permanent Alizarin Crimson at a value of 8 to paint the shadow side of the buildings, cast shadows and shadow sides of the trees. We're adding Permanent Alizarin Crimson to Burnt Sienna because Burnt Sienna contains black. By mixing it with Permanent Alizarin Crimson the color becomes more brilliant. Dry everything thoroughly before you continue.

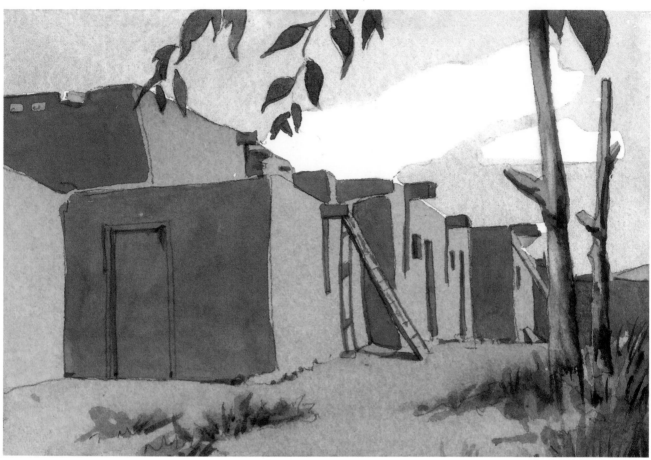

Step 4

Dilute Cobalt Blue in enough water so it's barely tinted, and paint the foreground in front of the houses. Notice this doesn't darken the value appreciably, but the thin film of color causes the foreground to appear flat. Paint the leaves and shrubs a gray-green shade using a mixture of Burnt Sienna and Cobalt Blue. Add a few dark accents with a mixture of Burnt Umber and Permanent Alizarin Crimson. This mixture should be very dark and toward red.

Intensity

The third dimension of color is *intensity*. Intensity refers to a color's strength, purity or saturation. We've all observed intensity changes in familiar-colored objects: a colored shirt fading with repeated washings; colors in the distance appearing less intense than colors at hand; brilliantly colored leaves of autumn gradually turning gray-brown before falling to the ground.

Most colors are at their maximum intensity right out of the tube, but you'll seldom use colors in their pure state. There are several ways to change the intensity of watercolor pigments. The intensity of any pure color is diminished by mixing it with its complement (across the color wheel) or by adding black.

Tip
The sky is not pure blue, nor is a grassy field pure green. The colors we see surrounding us are full of subtle grays. As you progress in your painting, you'll discover that no matter what your subject, the intensity of most colors will have to be adjusted.

The intensity of color in the strips here was reduced by the addition of black. Squint your eyes and notice that the value remains the same throughout the entire length of the bar. Only the intensity of the color was changed. On page 28 we discussed the value changes on the red and yellow strips. Look again and notice that the intensity of these colors diminishes with the addition of water.

Project 6: Discover Grays by Mixing Colors

Paint a swatch of red onto a clean piece of watercolor paper. Immediately add water around the edges of the puddle to reduce its intensity. Adding water or complementary colors one at a time varies the intensity. Notice the variety of beautiful grays you've made. Continue experimenting, and note the combinations you like for future use.

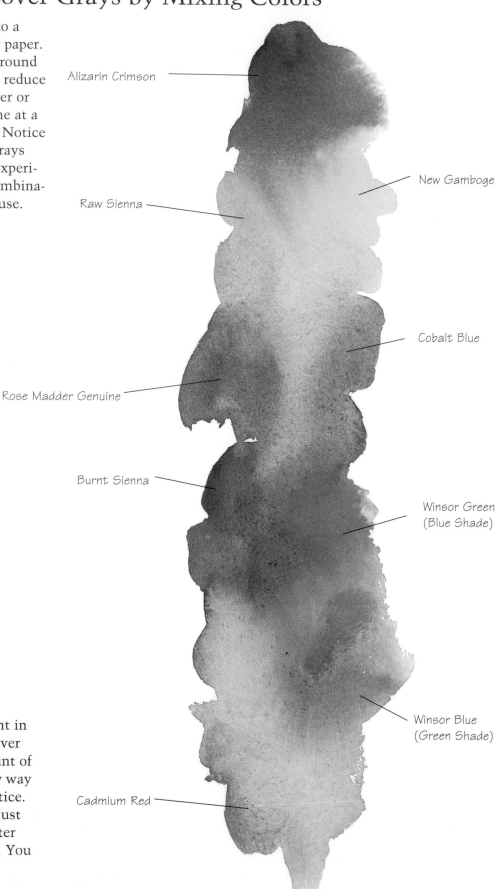

Alizarin Crimson

New Gamboge

Raw Sienna

Cobalt Blue

Rose Madder Genuine

Burnt Sienna

Winsor Green
(Blue Shade)

Winsor Blue
(Green Shade)

Cadmium Red

Tip
As you continue to paint in watercolor, you'll discover the trick is in the amount of water you use. The only way to get it right is to practice. Don't get discouraged; just keep trying. Every painter has to learn for himself. You can do it!

Project 7: Paint a Vase With Intense and Grayed Colors

In this project you'll learn how pure intense pigment can be modified with the addition of other colors.

The colors you will need are New Gamboge, Rose Madder Genuine, Winsor Green (Blue Shade) and Cobalt Blue.

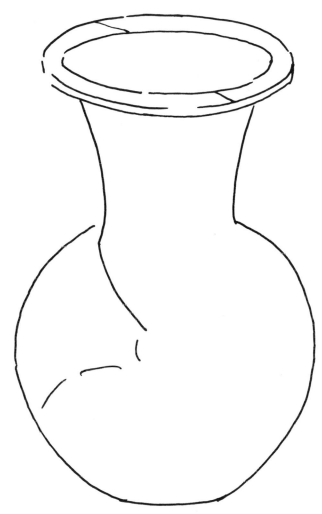

Step 1
Draw the outline of the jug onto a piece of watercolor paper.

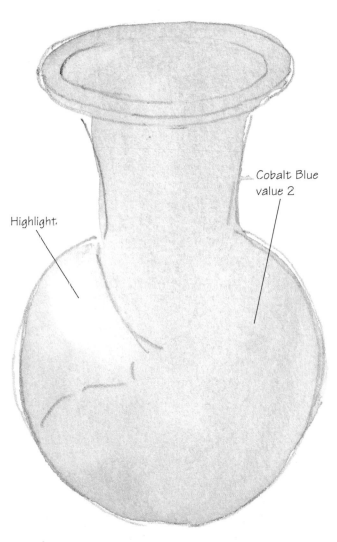

Highlight.

Cobalt Blue value 2

Step 2
Wet the entire surface of the jug with clear water, then add Cobalt Blue. Rinse your brush and squeeze out the water. Use the brush to lift out a highlight on the left side of the jug. Allow the paint to dry before you continue.

Important

Read these instructions before you continue. Steps three and four must be done in rapid succession while the paper is still wet, so have all your paints ready before you begin. The basic color is Cobalt Blue but have Phthalo or Winsor Green (Blue Shade), New Gamboge and Rose Madder Genuine moistened and ready for use. We'll alter the intensity of Cobalt Blue by "charging in" the other colors. Charging in a color means adding colors onto specific areas while the paper is still wet.

Step 3

Paint the shadow shape on the body of the jug with pure Cobalt Blue. This color can be at its maximum intensity. Work quickly using plenty of water. Immediately soften the edge along the rounded surface of the jug. Do this by running a slightly damp brush along the edge you want to soften. It's best to work from the dry side.

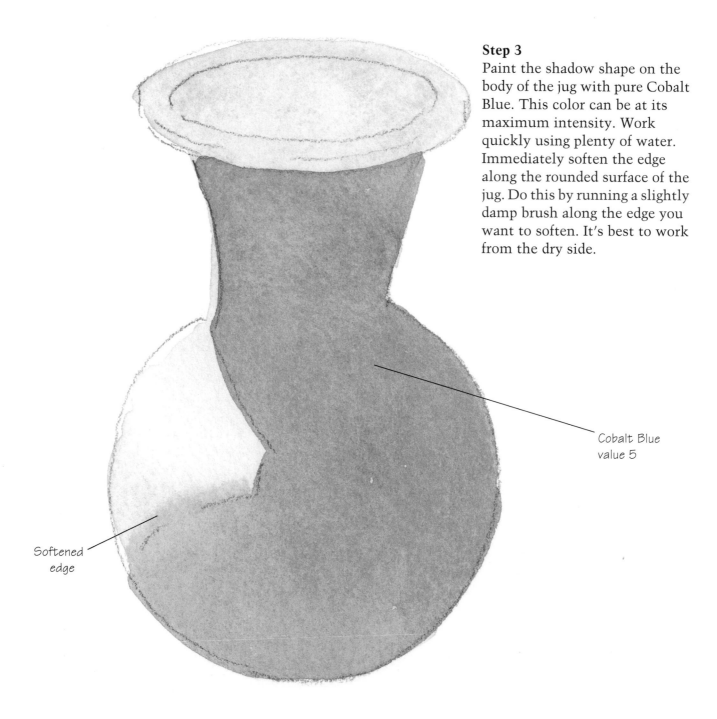

Cobalt Blue
value 5

Softened
edge

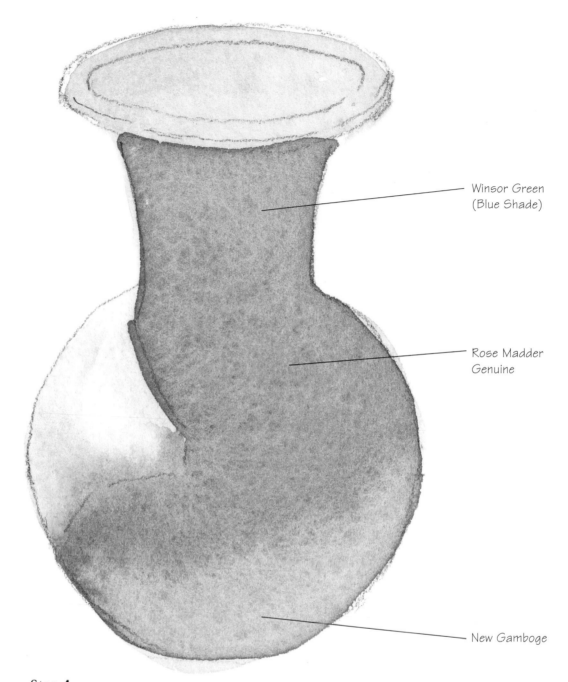

Winsor Green
(Blue Shade)

Rose Madder
Genuine

New Gamboge

Step 4
While the paint is still wet, add Winsor Green
(Blue Shade) onto the neck of the vase with a clean
brush. Clean your brush again and add New Gamboge across the bottom. Add a clean stroke of Rose
Madder Genuine just where the jug bulges out
from the neck. Dry before you continue.

Important
If the blue color has begun to
dry, stop and wait until the
surface is entirely dry before
you add more color. Then rewet the area with clear water
and add the colors one at a
time.

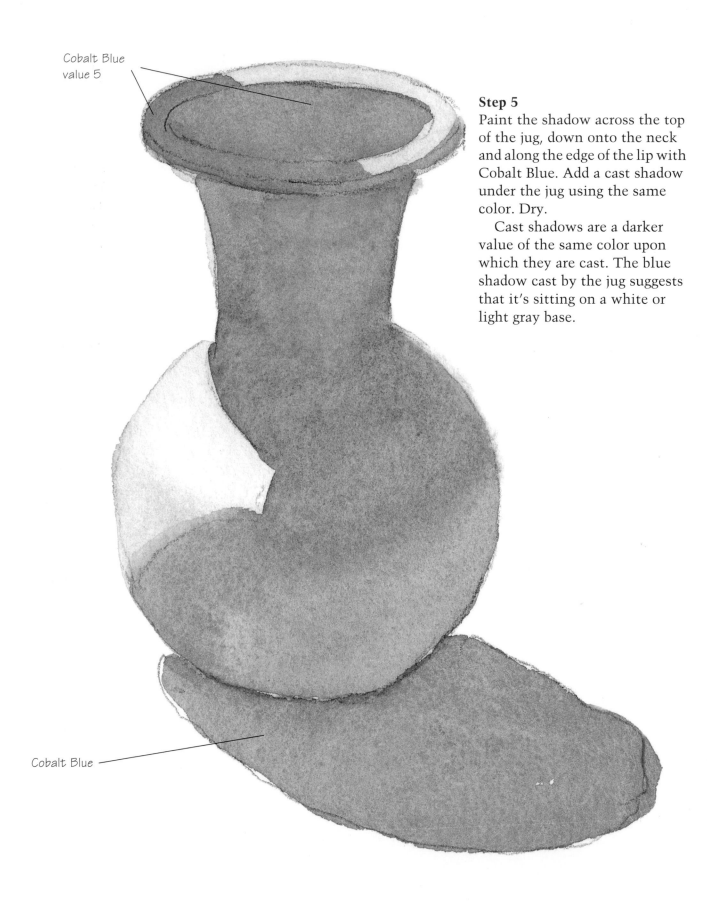

Cobalt Blue
value 5

Cobalt Blue

Step 5
Paint the shadow across the top
of the jug, down onto the neck
and along the edge of the lip with
Cobalt Blue. Add a cast shadow
under the jug using the same
color. Dry.

Cast shadows are a darker
value of the same color upon
which they are cast. The blue
shadow cast by the jug suggests
that it's sitting on a white or
light gray base.

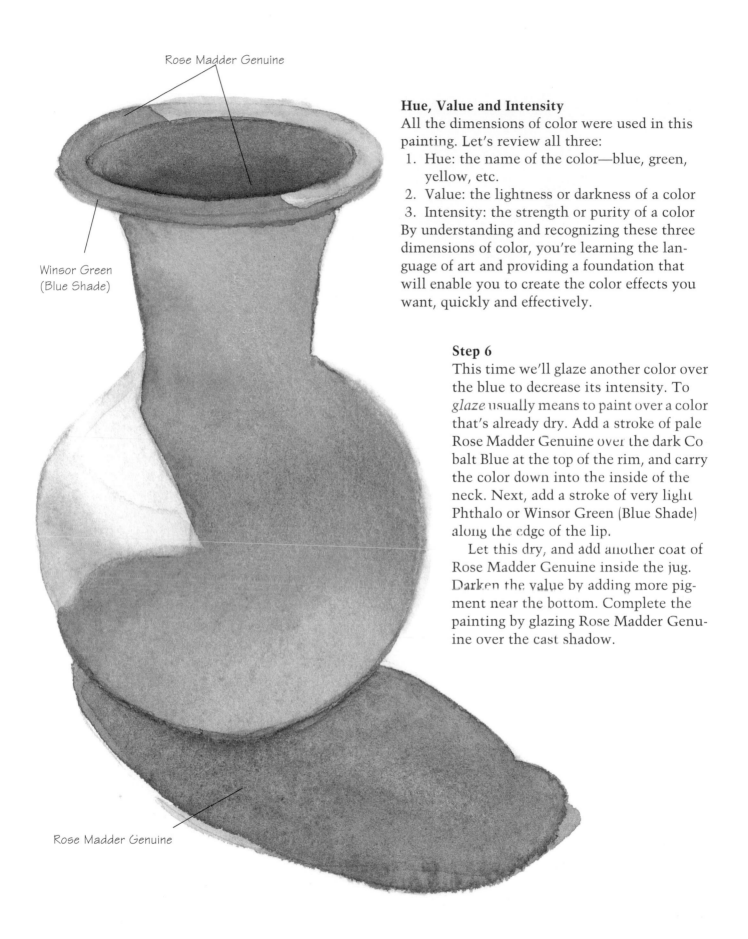

Rose Madder Genuine

Winsor Green
(Blue Shade)

Rose Madder Genuine

Hue, Value and Intensity

All the dimensions of color were used in this painting. Let's review all three:

1. Hue: the name of the color—blue, green, yellow, etc.
2. Value: the lightness or darkness of a color
3. Intensity: the strength or purity of a color

By understanding and recognizing these three dimensions of color, you're learning the language of art and providing a foundation that will enable you to create the color effects you want, quickly and effectively.

Step 6

This time we'll glaze another color over the blue to decrease its intensity. To *glaze* usually means to paint over a color that's already dry. Add a stroke of pale Rose Madder Genuine over the dark Cobalt Blue at the top of the rim, and carry the color down into the inside of the neck. Next, add a stroke of very light Phthalo or Winsor Green (Blue Shade) along the edge of the lip.

Let this dry, and add another coat of Rose Madder Genuine inside the jug. Darken the value by adding more pigment near the bottom. Complete the painting by glazing Rose Madder Genuine over the cast shadow.

More About Color

Colors Affect Each Other

The colors you use are affected by the colors around them. You'll soon discover you're making constant adjustments in hue, value and intensity as you paint. For instance, the first dark color you apply to a piece of paper may appear too dark because you're judging the dark value of the color against the white paper. As you add more color, it will take its place. Oil painters often cover their whole canvas with a middle value pigment to help them escape this initial shock. They can use white paint whenever they choose, but traditional watercolorists must save the paper for the white areas in their compositions. The illustrations here demonstrate how values affect one another.

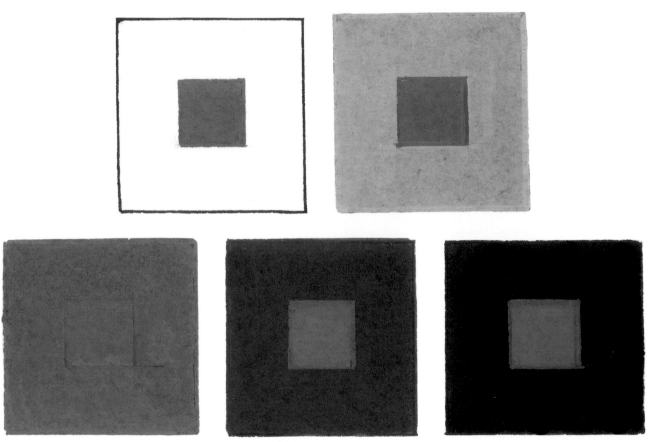

These five squares within squares illustrate how values can affect one another. All five center squares are the same value; only the value of the background squares has been changed. Notice how light the center square appears on the lower right when compared with the one on the upper left.

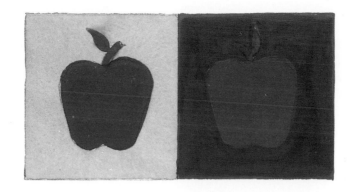

A

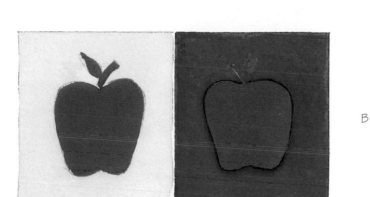

B

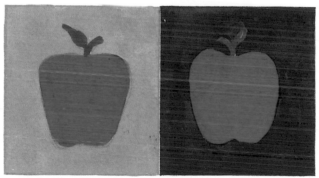

C

Whenever you use one color in a painting, it's always affected by the hues around it. That's why many artists make a color sketch before they begin a painting. Each pair of apples in the illustrations here was painted the same hue, but the background color changes their appearance.

A. Both apples were painted with the same color, but the red appears lighter and warmer against the red-violet background than against the blue one.

B. The red appears slightly orange against a green background. Opposed to yellow, the apple looks much cooler.

C. Even though they were painted with the same color, the apple on the green background appears much darker and bluer than the one with a violet background.

Color Proportion

Color can be used in good taste or it can be abused. Even though all the hues in the color wheel are available for use, the experienced artist uses fewer hues but takes advantage of the color differences she can create by varying intensity and value. For instance, green can be varied to produce turquoise or grayed to become green-brown. Decorators use this same theory when planning a comfortable living space. Quiet background hues are used to set off sparkling accents of brilliant color. The same principle applies to our paintings. As artists we must be careful not to use several intense colors in same-sized areas.

On the left, all four swatches of color are of equal importance. The red becomes more dominant when the adjacent colors are subdued.

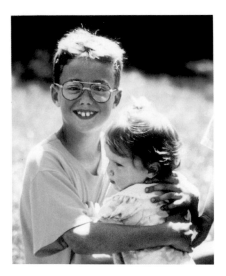

In this photograph, the number and variety of brilliant colors diminish the importance of the central figures.

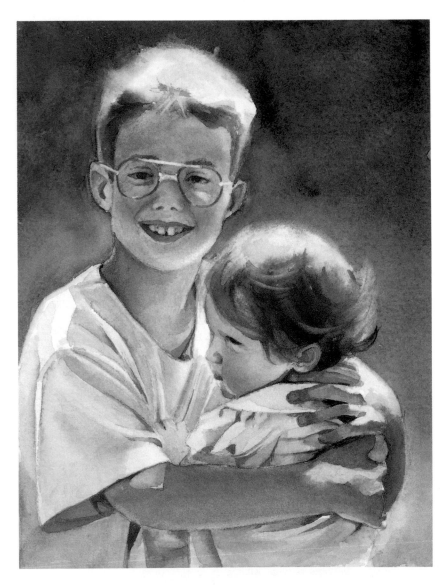

By reducing the background area and graying the color, the children in this painting become the center of attention.

Limited Palette

For a painter, the word *palette* has two meanings: It can mean the tray on which we mix our pigments, or more importantly, it can mean the group of colors we use in our paintings. When we speak of a limited palette (or a set palette), we mean the artist has used only a select number of pigments to complete her painting. Study the paintings you really enjoy—you may be surprised at the limited range of hues the artist has used.

The best way to gain confidence and become familiar with your palette is by mixing color. Use a scrap of watercolor paper, and vary the amount of water and pigments with each mixture. Start with one pigment and add others one at a time, letting the colors blend on the paper. Be sure to identify the combinations you like best so you can repeat them. By combining complementary pigments in light values, you can create a variety of beautiful grays.

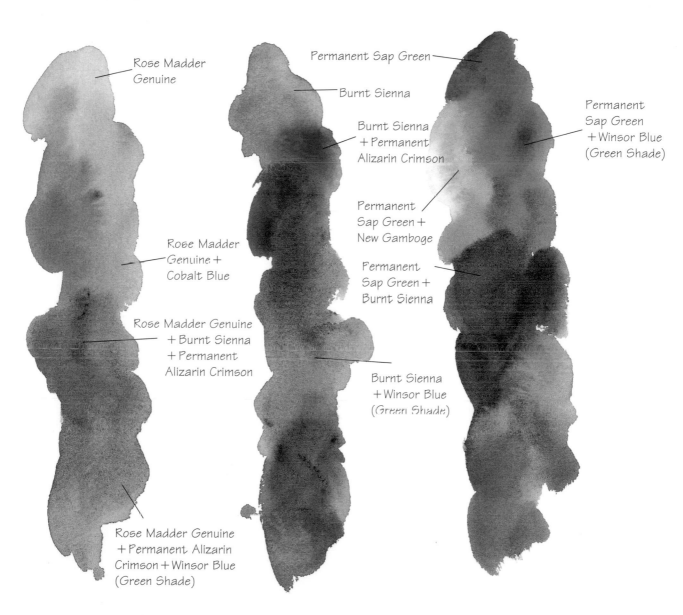

Rose Madder Genuine

Rose Madder Genuine + Cobalt Blue

Rose Madder Genuine + Burnt Sienna + Permanent Alizarin Crimson

Rose Madder Genuine + Permanent Alizarin Crimson + Winsor Blue (Green Shade)

Permanent Sap Green

Burnt Sienna

Burnt Sienna + Permanent Alizarin Crimson

Permanent Sap Green + New Gamboge

Permanent Sap Green + Burnt Sienna

Burnt Sienna + Winsor Blue (Green Shade)

Permanent Sap Green + Winsor Blue (Green Shade)

The best way to become familiar with your palette is by mixing colors. Work on a scrap of good watercolor paper, and be sure to note the combinations you like best.

Project 8: Paint a Landscape Using Aerial Perspective

Advancing and Receding Color

It's important to realize that some colors appear to come forward, and others appear to recede. Warm colors such as yellow, orange and red appear closer to us than cool blues, greens and violets. Because of atmospheric haze, the color of distant objects also appears lighter in value and less intense than those close at hand. The use of color and value to create the illusion of depth in a painting is called *aerial perspective*.

In this project you'll learn how to plan a landscape painting and use color and value to create the illusion of space. Here are two points to keep in mind:

1. Foreground objects are warmer, darker in value and more distinct in form.
2. Distant objects are cooler, lighter in value and less distinct in form.

The first step is to organize the landscape. Under normal conditions the sky is the lightest area in a landscape painting. The flat ground is darker in value and extends into the foreground. The mountains, buildings and trees appear darker still and are located in the middle distance. A ragged tree in the immediate foreground will be the dominant feature of our landscape. The chart here will help you plan your landscape.

Advancing and Receding Color

AREA	HUE	VALUE	INTENSITY	FORM
Sky	Usually Cool	Usually light (1-3)	Low	Soft, Rounded
Distance	Combination Warm and Cool	Middle Values (4-6)	Middle	Rounded Fast Transitions Some hard edge
Foreground	Usually Warm	All Values Reserved Values 9-10 For Foreground Darks	High	Textured Graphic Detail

Values become darker as they approach the foreground.

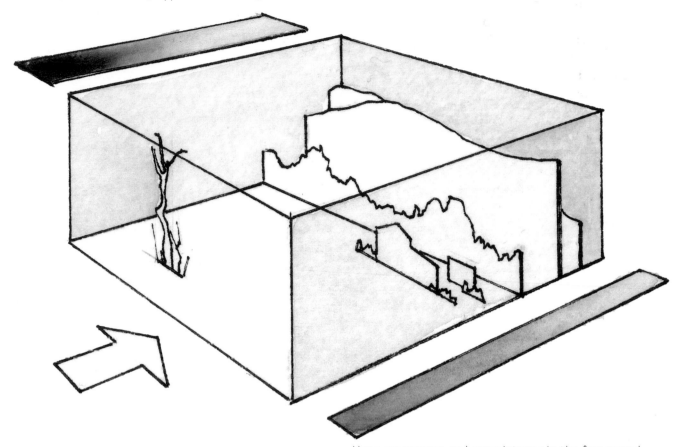

Hues are warmer and more intense in the foreground.

Don't think of a landscape painting as an unlimited vista, but rather a view through an open box that has one closed end. The sky, if included, should be at the distant end of the box. With this image in mind, planning a landscape seems less daunting.

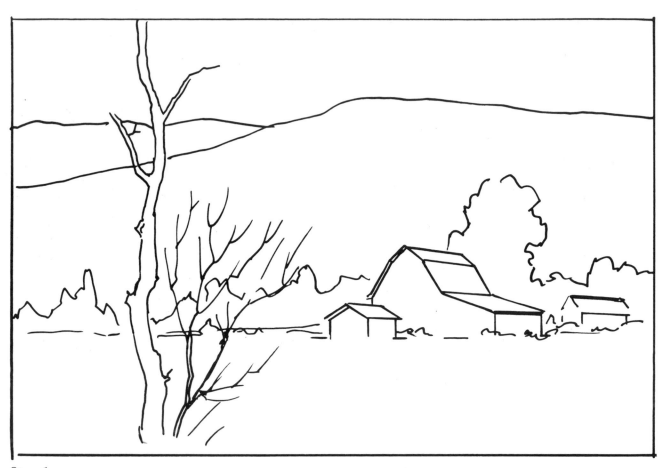

Step 1
Enlarge the drawing and sketch
it onto your watercolor paper.

Tip
The first law of color har-
mony is to always put a bit
of warm color into cool
areas and some cool into
warm areas.

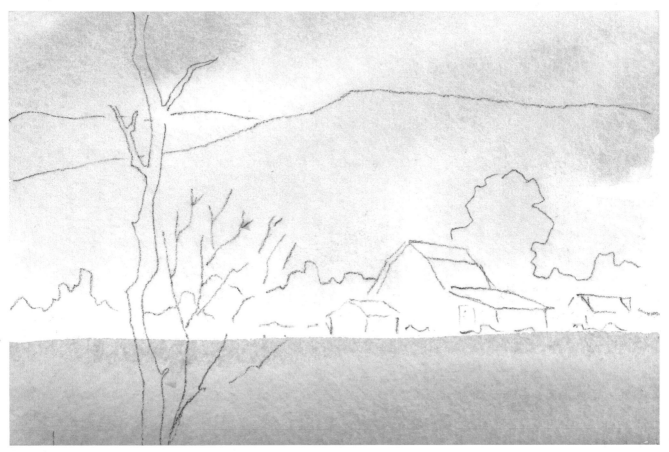

Step 2

Let's limit our palette to two colors for this project: Burnt Sienna to represent the warm hue and French Ultramarine Blue to represent the cool one. As before, paint either color onto the watercolor paper and add the other to it.

Begin with the sky. Wet the area thoroughly with clear water down to the base of the mountain. Immediately add blue, and let the pigment move freely on the wet surface. Add just enough Burnt Sienna to suggest wispy clouds or dust in the air that might cause a warm glow. Dry the area before continuing. If you use a blow-dryer, keep back far enough so the entire area dries evenly.

Now turn to the foreground which extends to the base of the trees. This horizontal plane is darker than the sky. Dilute French Ultramarine Blue with enough water to make a light value of about 3. Now, tip your paper up at a slight angle and paint a wide stroke at the base of the trees. Try to do this with one stroke of your brush. Try another just below and touching the first, only this time add a bit of Burnt Sienna; add another until the bottom stroke is composed entirely of Burnt Sienna. Dry.

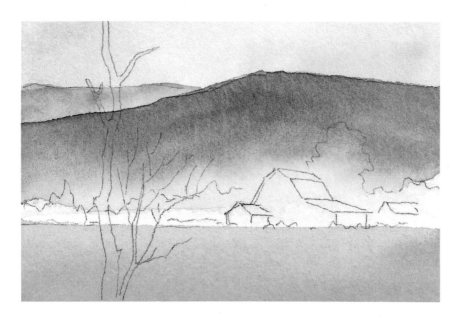

Step 3

The next large area to paint is the mountain. You've probably noticed that because of atmospheric haze, the base of distant mountains often appears lighter than the topmost peak. To suggest this effect, paint a passage of clear water along the base of the mountain; skip to the top and paint along the ridge, bringing the color down to the place you already moistened. The mountain is a combination of warm and cool colors. Remember to apply either the blue or sienna to the paper, then add the other color to it.

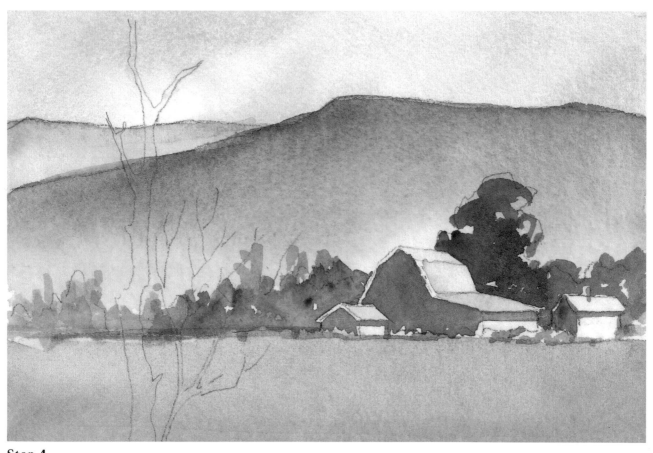

Step 4

Be sure the mountain is dry before painting the trees. Start with Burnt Sienna and add blue. Suggest a line of trees at the base of the mountain by using brush strokes of varying lengths. Let the brush strokes touch each other to form a flowing mass. Next, paint the shadow side of the buildings. Don't worry if some of the previous background colors have flowed into this area. After you paint the trees and buildings, you probably won't notice any problem.

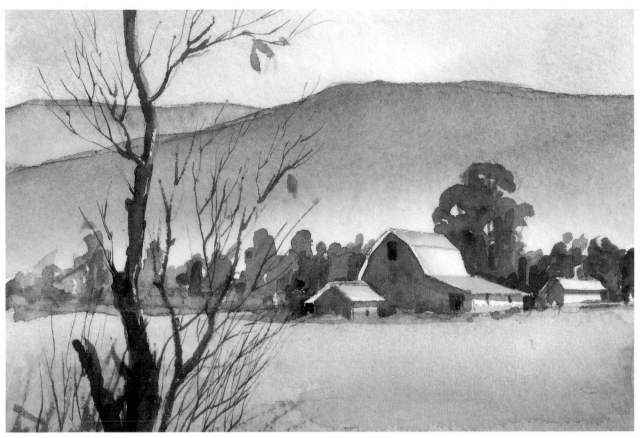

Step 5

Now it's time to add darks and accents. Use slightly darker values to suggest a few trees in front of those already painted. Then darken the value further to suggest windows and a barn door.

Paint the tree and twigs in the immediate foreground. The darkest darks and most brilliant colors should be reserved for this area.

When you've finished, look at your painting from across the room. I hope you're pleased with your work, but if there's a problem, put it away and look at it later with a fresh eye. If the sky is too dark, you've probably used too much Burnt Sienna. If your painting seems flat, your value contrasts may be weak.

Tip

If your brush is too large to paint small branches, use a dry twig from a tree instead. Practice painting with the stick on a scrap of paper before you begin. Many artists use twigs for this purpose.

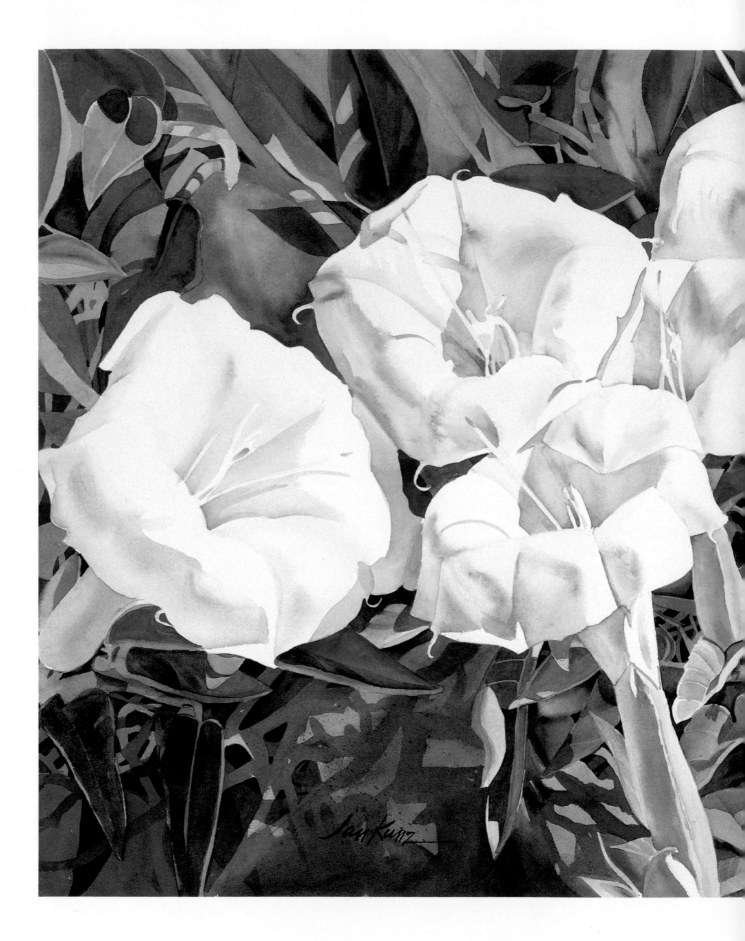

PHYSICAL PROPERTIES OF WATERCOLOR PIGMENTS

Thcrc arc two things you'll discovcr about watercolor pigments: (1) they dry much lighter than when you apply them, and (2) some of thc pigments will stain the paper, while others will wash off easily. Learning what to expect of the pigments you use can make watercolor painting even more fun.

White Glory
22″×30″ (55.9cm×76.2cm)

Opaque and Transparent Colors

When you made the color wheel in chapter one, you may have noticed some colors were more opaque than others. For instance, Cadmium Red may have seemed more dense than Permanent Alizarin Crimson. The fact is, there are two kinds of watercolor pigments: *opaque* and *transparent*.

It's possible to achieve a veiled appearance by painting an opaque color over a transparent one, and in small accents, opaque colors can achieve a fair degree of opacity.

When light rays penetrate the thin film of pigment deposited by a transparent color, they reflect the white paper beneath and impart a brilliant glow. The more the white paper is allowed to reflect, the more luminous the effect. When light is returned from an opaque color, it reflects only the pigment granules. It won't take long before you'll recognize the difference between transparent and opaque pigments from the way they flow onto the watercolor paper.

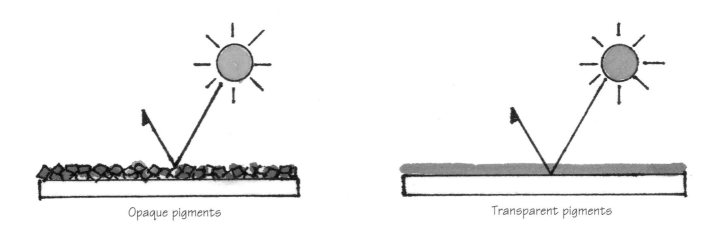

Opaque pigments

Transparent pigments

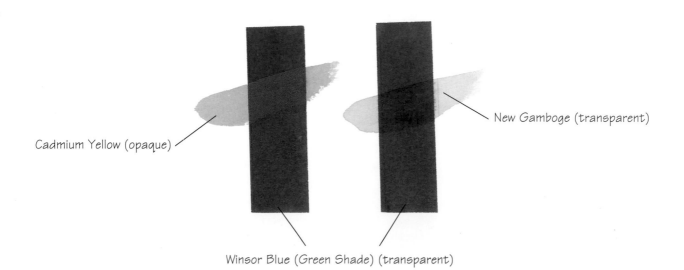

Cadmium Yellow (opaque)

New Gamboge (transparent)

Winsor Blue (Green Shade) (transparent)

High- and Low-Intensity Pigments

Watercolor pigments capable of brilliant colors and containing no black are referred to as *high-intensity pigments*. *Low-intensity* pigments contain some degree of black and are less intense in color. Most watercolor pigments fit into one of these four groups:

1. High-intensity opaques
2. Low-intensity opaques
3. Low-intensity transparent
4. High-intensity transparent

The following chart will help you compare various watercolor pigments.

Properties of Watercolor Pigments

Pigment	Darkest Value	Opaque	Paper Staining	Transparent	Black Content
GROUP 1: HIGH-INTENSITY OPAQUES					
Cadmium Yellow	2±	Very	Slight	No	None
Cadmium Orange	3±	Very	Slight	No	None
Cadmium Red	4±	Very	Slight	No	None
Vermilion	4±	Yes	Slight	No	None
Cerulean Blue	4±	Very	Slight	No	None
Cobalt Blue	5±	Yes	Slight	Slightly	None
GROUP 2: LOW-INTENSITY OPAQUES					
Yellow Ochre	3±	Yes	Slight	No	Slight
Raw Sienna	4±	Yes	Medium	No	Slight
Raw Umber	6±	Yes	Slight	No	High
Burnt Sienna	6±	Partly	Medium	Slightly	Slight
Burnt Umber	8±	Yes	Slight	No	High
GROUP 3: LOW-INTENSITY TRANSPARENTS					
Brown Madder (Alizarin)	8±	No	High	Yes	Medium
Indigo	9±	No	High	Yes	Medium
Payne's Gray	10	No	Medium	Yes	Medium
Permanent Sap Green	6±	No	High	Yes	Medium
GROUP 4: HIGH-INTENSITY TRANSPARENTS					
New Gamboge	2±	No	Slight	Yes	None
Winsor Red	5±	Slightly	Medium	Yes	None
Alizarin Crimson	8±	No	High	Yes	None
Winsor Blue	10	No	High	Yes	None
Winsor Green	10	No	High	Yes	None
French Ultramarine Blue	8±	Slightly	Slight	Nearly	None

Watercolor Pigments in This Book

Let's take a closer look at the watercolor pigments we'll use to complete the exercises in this book.

GROUP 1: HIGH-INTENSITY OPAQUES

These pigments have a very short value range. They stay more or less suspended in water until dry and are therefore easy to manipulate. They're useful for bright accents and overpainting in small areas.

A-CADMIUM YELLOW

A warm (toward orange) intense yellow. Very opaque. Can be used for bright accents.

B-CADMIUM ORANGE

A pure orange. Mixed with Winsor Green (Blue Shade) or Winsor Blue (Green Shade) creates a rich gray-green in light and middle values.

C-CADMIUM RED

An intense warm red (toward orange). Not capable of extremely dark values. Useful in glazes to impart a rosy glow.

D-COBALT BLUE

Close to a pure primary blue and somewhat transparent. Works well as a glaze and mixes with other colors to create beautiful secondary colors.

A B C

GROUP 2: LOW-INTENSITY OPAQUES

These pigments have a variety of value ranges. But when used alone in dark values, they appear lifeless.

A-RAW SIENNA

This color is similar to Yellow Ochre, but is more granular in character. Mixes with Rose Madder Genuine to create a beautiful gold color.

B-BURNT SIENNA

This burnt orange color is a favorite with landscape paint-

ers. It creates beautiful grays when mixed with blue. I like to use this color combined with red for warm dark areas.

C-BURNT UMBER

When mixed with Permanent Alizarin Crimson, Burnt Umber makes wonderful warm blacks for use as accents in small places. This color is best mixed with long-range high-intensity pigments and should never be used alone in dark values.

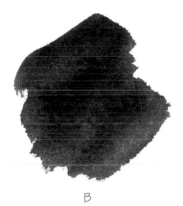

A B

GROUP 3: LOW-INTENSITY TRANSPARENTS

These colors have a long value range. They can be diluted to pale delicate colors, but like the low-intensity opaque pigments, these appear dull and lifeless if used alone in values darker than 6. Colors in this group include Brown Madder Alizarin, Indigo, Prussian Blue and Permanent Sap Green. The low-intensity transparents we use in this book are Permanent Sap Green and Payne's Gray.

A-PERMANENT SAP GREEN

An intense warm green (toward orange). Stains the paper

and is difficult to conceal. Use sparingly or mixed with other colors for exciting secondaries.

B-PAYNE'S GRAY

A cool gray that dries considerably lighter than when first applied. Useful for value sketches. This color can be habit forming, and overuse can result in gray paintings. This color doesn't have a permanent place on my palette.

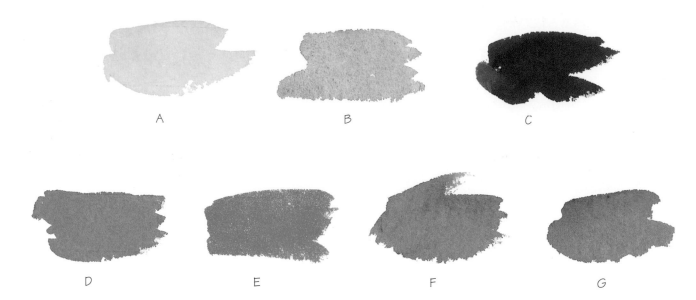

GROUP 4: HIGH-INTENSITY TRANSPARENTS

Most of these brilliant pigments have long value ranges and remain brilliant at all levels. These pigments contain no black and mix well with other pigments to create lively dark colors.

A-NEW GAMBOGE

A clean brilliant yellow. Don't confuse this color with Gamboge, which is dull by comparison. Mixes well with other colors to make beautiful secondaries.

B-ROSE MADDER GENUINE

This clear pink works well as a glaze to warm certain passages. It lifts easily and mixes well with other colors.

C-PERMANENT ALIZARIN CRIMSON

A cool transparent red with a long value range. Mixes with Burnt Sienna or Burnt Umber to create beautiful warm darks, or with French Ultramarine Blue for a luminous purple.

D-HOOKER'S GREEN

A clear permanent green that has great staining power. Mixes well with other colors to create a variety of green shades.

E-WINSOR GREEN (BLUE SHADE)

An intense green with a long value range. Cool in character, it is similar to Phthalo, or Phthalocyanine Green. Blends with Raw Sienna to suggest silver.

F-WINSOR BLUE (GREEN SHADE)

A cool transparent blue, beautiful by itself, but tends to dominate and should be modified with another color. Also called Phthalo, or Phthalocyanine Blue.

G-FRENCH ULTRAMARINE BLUE

Can be considered a transparent or opaque color. Tends to dry lighter than expected. Mixes well to make clear secondary colors.

Beautiful Grays

Grays or neutrals are created by combining colors from opposite sides of the color wheel. In chapter one you saw how beautiful grays can be created by laying complementary colors next to one another and allowing them to blend on the paper.

An otherwise dull gray passage can be made more interesting by letting the pigments mix on the paper and/or by charging various colors into the wet surface. The first watercolor sketch here was painted with Cobalt Blue and Raw Sienna mixed in the palette. In the next example, Cobalt Blue was painted onto the paper, and Raw Sienna was immediately added so the pigments could blend on the paper. In the last example, Cobalt Blue and Raw Sienna were mixed on the paper and then Burnt Sienna and Rose Madder Genuine were charged in one at a time while the surface was still wet. It's important to give life to whatever color you use by making it "move." Avoid painting a solid color and value from side to side or up and down in any large area.

A

B

C

Brilliant Dark Values

Long-range pigments such as Permanent Alizarin Crimson or Winsor Blue (Green Shade) contain no black and are capable of brilliant dark values. The question is: How can we mix a brilliant dark value of a color with a short value range? The answer: to combine it with a long-range transparent color from the same side of the color wheel. By combining related (or analogous) hues, we arrive at brilliant dark values. Renoir, Monet and other Impressionists who sought to convey the feeling of sunlight in their painting often employed this technique to achieve brilliant dark values.

Tip
It doesn't take long for colors in the center of your palette to run together and create some pretty interesting—or yucky—grays. Keep your palette and pigments clean, and you'll be sure your colors aren't contaminated or grayed.

Mud
Mud happens! We used Burnt Sienna and French Ultramarine Blue in our experiment with warm and cool colors on page 51. These colors are on opposite sides of the color wheel. If we combine them in dark values, the resulting color can be muddy. Remember, whenever you mix color opposites in dark values, you run the risk of creating mud!

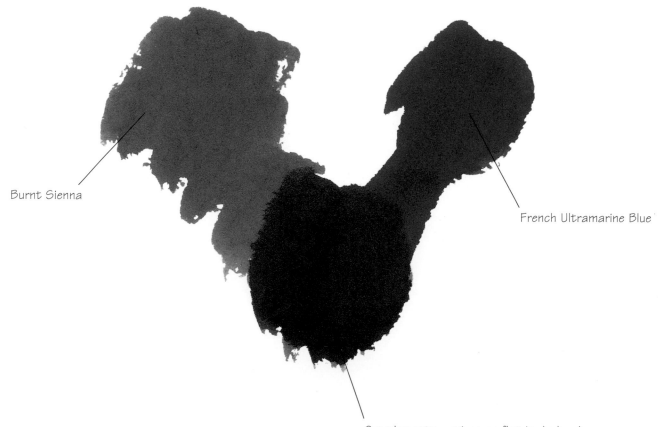

Burnt Sienna

French Ultramarine Blue

Complementary mixes go flat in dark values

Project 9: Create Brilliant Dark Values

In this project you'll learn how to:

1. Use the pigment chart on page 57, color wheel on page 29 and value scale also on page 29 to mix brilliant dark values.
2. Recognize a 40-percent value difference. This is the value difference between the sunlit and shadow side of objects viewed outside on a sunny day.

We'll combine any pigment from group one, two or three with a long-range pigment from the same side of the color wheel in group four.

Begin by drawing several cubes onto scraps of watercolor paper. Have fresh pigment ready.

Cube 1. We'll begin with a simple value change. Paint one side of the cube Cobalt Blue, and determine the value after it has dried. Consult the pigment chart to see which blue pigment is capable of a value 40 percent (or four values) darker than the side you have painted. Paint the shadow side.

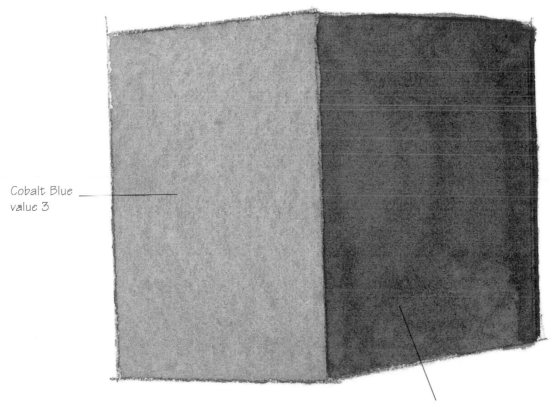

Cobalt Blue
value 3

Winsor Blue (Green Shade) +
Cobalt Blue
value 7

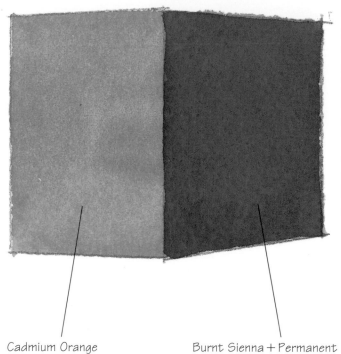

Cube 2. This time we'll use a short-range pigment. Paint Cadmium Orange—almost straight out of the tube—onto one side of a cube. We might consider adding Burnt Sienna to the dark side. Burnt Sienna is burnt orange, but this pigment contains black and it's value range isn't long enough to achieve a 40-percent value difference. Your pigment chart shows you that Permanent Alizarin Crimson has the value range needed. By combining Permanent Alizarin Crimson with Burnt Sienna the black is diminished and we arrive at a brilliant dark value.

Cadmium Orange
value 3

Burnt Sienna + Permanent
Alizarin Crimson
value 7

Cube 3. Yellow, at its most intense, is only about value 2, so we must mix it with another hue to arrive at a dark value. Because of its unique position at the top of the color wheel, yellow has analogous colors on both the warm and cold sides. We must decide whether we want warm or cool dark yellow shapes. Once the decision is made we must stick with our choice.

We'll begin on the warm side. By consulting the pigment chart we see that Raw Sienna, a gray-yellow, is only capable of value four even at it's most intense. Our best choice is to combine Permanent Alizarin Crimson and Raw Sienna to arrive at a clean dark value.

Cadmium Yellow
value 1+

Raw Sienna + Permanent
Alizarin Crimson
value 5+

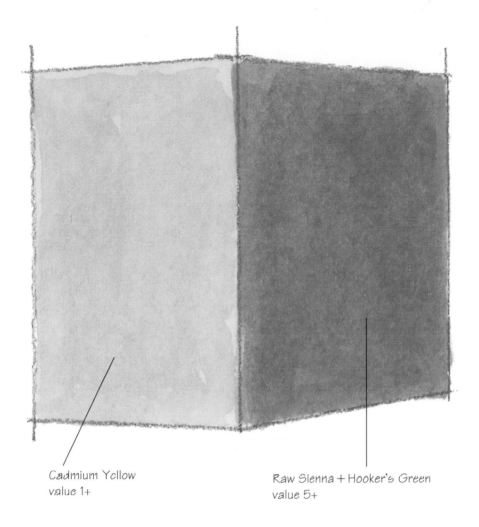

Cadmium Yellow
value 1+

Raw Sienna + Hooker's Green
value 5+

Cube 4. Another possibility to use with yellow
is to hop down the other side of the color wheel
to green and combine Raw Sienna with either
Winsor Green (Blue Shade) or Winsor Blue (Green
Shade). These pigments contain no black; either
would make a suitable choice.

Summary of Watercolor Pigment Properties
1. Pigments can be classified as either transparent or opaque.
2. Complementary mixtures make beautiful grays in light and middle values.
3. Charging colors into a gray passage can add interest and life.
4. Muddy color is the result of mixing complementary colors in values darker than 6.
5. To create brilliant dark values, combine short-range colors with long-range transparent colors from the same side of the color wheel.

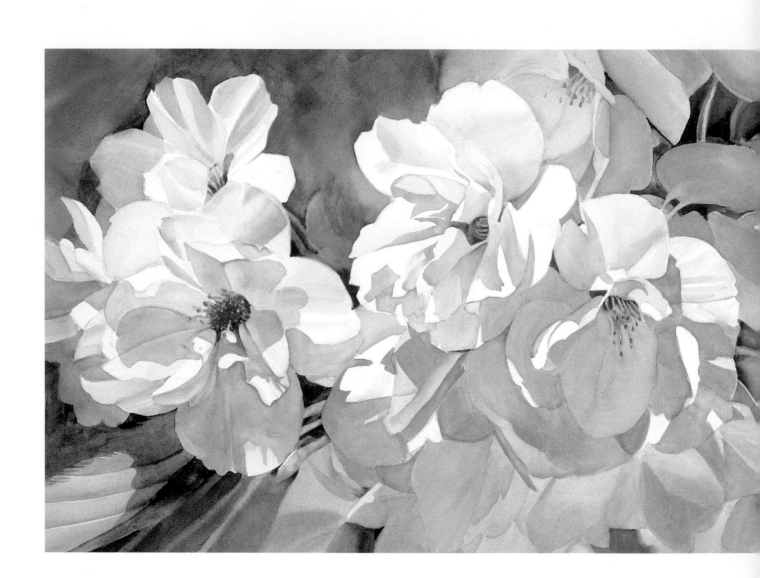

WHAT COLOR IS IT?

A student of mine was traveling with his sister when he saw a beautiful tree dressed in flaming autumn color. He exclaimed, "Look at that! Just look at that!" She replied, "What? What do you see?"

While most of us wouldn't miss such a beautiful sight, it's the first obligation of an artist: to learn to see. You will see color more easily if you learn where to look and what to expect. This information is vital to any artist no matter what their medium. Before long you'll be looking for the subtle nuances of color everywhere in nature.

Symphony
16″×35½″ (40.6cm×90.2cm)

Seeing Color

We know a pond mirrors the sky, but so does every other object exposed to the sky. Let's try an experiment so you can see this for yourself. Try this in the morning or late afternoon because the brilliant midday sun makes subtle shadows less obvious.

Place a white box outdoors on a piece of solid-colored paper. Arrange it so one side faces the sunlight and the cast shadow falls across the paper. Notice how the top of the box reflects the sky and is bluer than the vertical side facing the sun. The vertical side facing the sun appears warmer in color temperature (more toward yellow). The side turned from the sun also reflects the sky and is cool in color temperature.

Now look at the shadow side. This side is not only 40 percent darker than the sunlit side, but also receives reflected light from the paper under-neath or from adjacent objects that are in direct sunlight.

The shadow cast by the box is the same hue as what it's cast upon and is somewhat more than 40 percent darker than the sunlit surrounding area. You won't see reflected light in a cast shadow.

At the bottom of the box, you'll see a small, dark line or crevice. These "underneath" darks are warm because they aren't influenced by the sky.

Tip
On a sunny day, subtle differences in color and color temperature appear everywhere in nature. An artist can make a petal appear to bend and a table appear to lie flat by making use of these subtle color temperature differences.

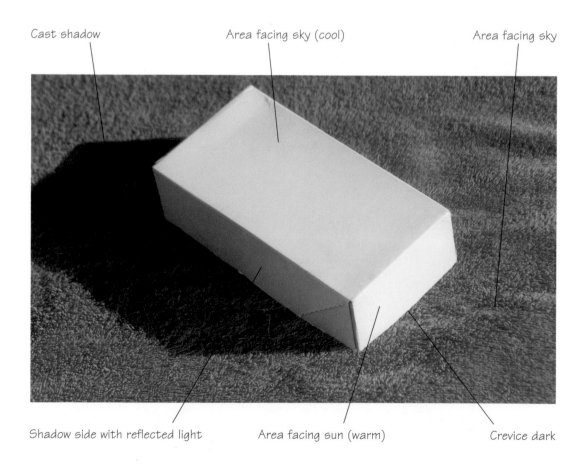

Cast shadow Area facing sky (cool) Area facing sky

Shadow side with reflected light Area facing sun (warm) Crevice dark

Translucent Light

Floral painters have an additional aspect of color and light to consider: Light penetrates the petals of a flower or a leaf and affects the color and value. In general, the light penetrating a petal warms the color temperature. The value is also affected. The key is careful observation.

Study the light on the peony in the photo on this page. Notice that where light penetrates only one petal, its value is lighter and somewhat warmer than where several petals are involved.

Tip
Since objects in sunlight often have reflected light on their shadow sides, artists are free to add reflected light to objects in paintings whether it's there or not.

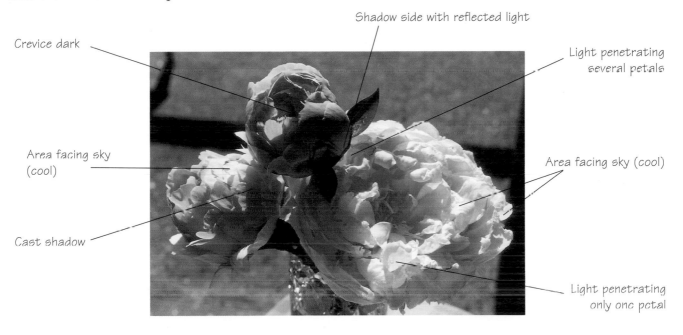

Shadow side with reflected light

Crevice dark

Light penetrating several petals

Area facing sky (cool)

Area facing sky (cool)

Cast shadow

Light penetrating only one petal

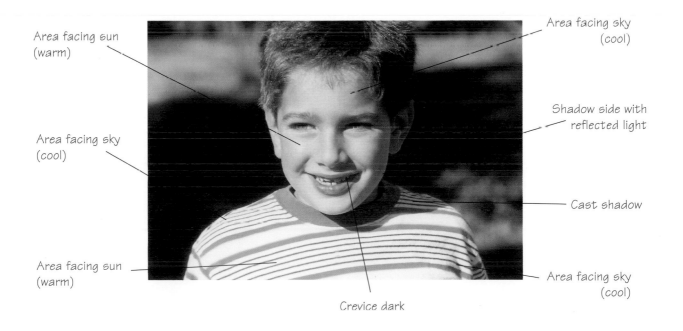

Area facing sun (warm)

Area facing sky (cool)

Area facing sky (cool)

Shadow side with reflected light

Area facing sun (warm)

Cast shadow

Crevice dark

Area facing sky (cool)

Project 10: Learn to Paint Objects in Sunlight

We'll start with the simple white box. Any color we add must be subtle so as not to destroy the illusion of white.

Step 1: Background
Draw a box like you see on the opposite page onto watercolor paper. Paint a blue background behind the box to suggest a sunny day. Let the surface dry before continuing. Let's suppose the sunlight is from the right side, so the side facing that direction will be warm in color temperature.

Step 2: Sunlit Side
Wet the sunlit side and paint a trace of Cadmium Yellow along the edge farthest from the light, but not over the entire surface. Keep the color light in value so it imparts a glow, but doesn't appear yellow. Dry thoroughly.

Step 3: Top of Box
Wet the top and add a trace of Cobalt Blue in the area away from the direction of the light. Once again dry thoroughly.

Step 4: Surface Box Rests On
Paint the area upon which the box is resting. This is a horizontal surface, so it's somewhat cool in color temperature. Use Permanent Alizarin Crimson and dry thoroughly before you continue.

Step 5: Shadow Side of Box
Painting the shadow side is a bit tricky, so I suggest you read this part through before you begin. You may want to try this first on a scrap of watercolor paper.

The shadow side is 40 percent darker than the sides in sunlight. We know muddy colors result from complementary mixtures in values darker than 6. But since this is a white box, the shadow side need only be a value 4 or 5, so a neutral blue-gray will work. Also remember the shadow side can receive reflected light from the red surface below the box.

Proceed by painting the entire shadow side with a mixture of Cobalt Blue and Burnt Sienna that is 40 percent darker than the sunlit sides. Wash your brush before it dries, and wipe out most of the water on a paint rag. Lift out some of the color at the bottom of the box and immediately add a swatch of Cadmium Orange. This color represents reflected light and should be just that—light. Let the colors blend. A "blossom" can occur when more water is added to a partially dry passage, so you must work fast. If you create a blossom, you may have waited too long or added too much water.

Step 6: Cast Shadow
To paint the cast shadow under the box, determine the value of the red surface and then paint the cast shadow four values darker. Permanent Alizarin Crimson has a long value range so you can arrive at a dark enough value by adjusting the amount of water in your brush. The edge where the cast shadow touches the sunlit area appears cold to our eyes because we're comparing it to the area in sunlight. However, look within the shadow; it may appear to have more color. Suggest this effect by painting the leading edge of the shadow a cool red. Then charge a warmer red into the shadow shape nearer the base of the box. I used Cadmium Red for this purpose. Be careful to maintain the same value.

Step 7: Crevice Darks
Any dark area that's not affected by the sky is usually warm in color temperature. To suggest the dark wedge shapes under the box, mix Burnt Umber and Permanent Alizarin Crimson. Use very little water and keep the mixture toward red. These small wedge shapes help "anchor" the box.

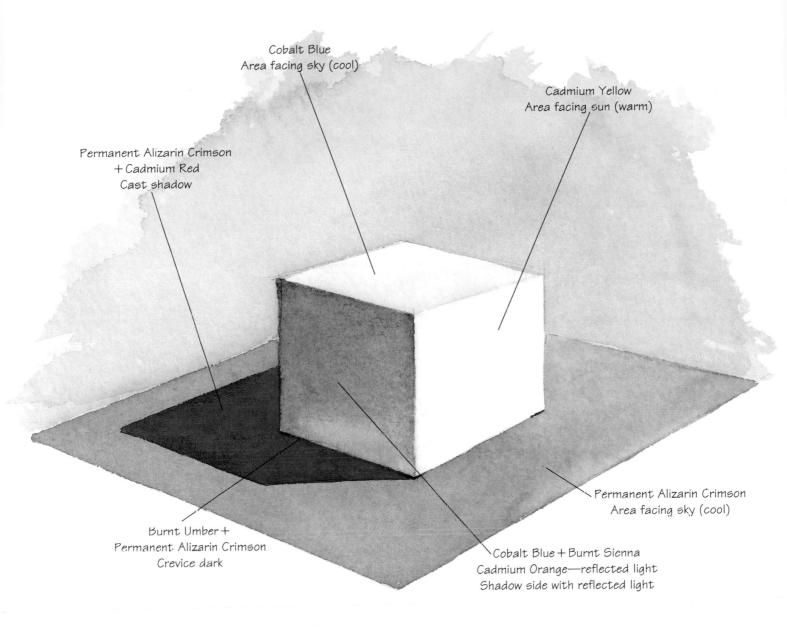

Cobalt Blue
Area facing sky (cool)

Cadmium Yellow
Area facing sun (warm)

Permanent Alizarin Crimson
+ Cadmium Red
Cast shadow

Permanent Alizarin Crimson
Area facing sky (cool)

Burnt Umber +
Permanent Alizarin Crimson
Crevice dark

Cobalt Blue + Burnt Sienna
Cadmium Orange—reflected light
Shadow side with reflected light

Tip
A blossom can occur when more water is
added to a partially dry passage. If you create
a blossom, you may have waited too long or
added too much water.

Project 11: Paint a Rusty Pot

In this project you'll learn how to add brilliant color to dull objects in your paintings. To do this, utilize what you've learned about painting objects in sunlight:

1. Observe the 40-percent value rule.
2. Use color temperature changes to your advantage.
3. Choose analogous colors to create dark values.
4. Add the illusion of reflected light.

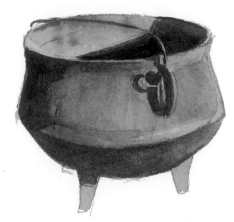

This rusty cooking pot, which I've painted just as it really appears, has an interesting shape, but the colors are dull and uninteresting.

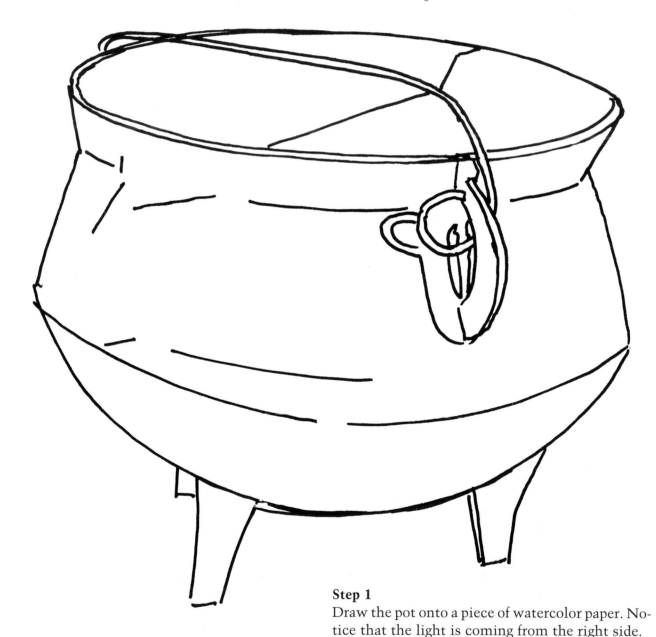

Step 1
Draw the pot onto a piece of watercolor paper. Notice that the light is coming from the right side.

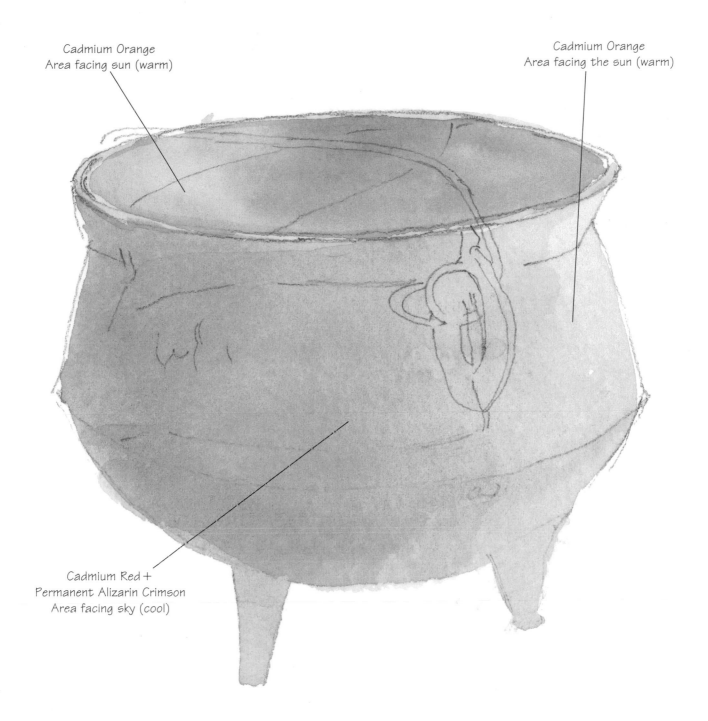

Cadmium Orange
Area facing sun (warm)

Cadmium Orange
Area facing the sun (warm)

Cadmium Red +
Permanent Alizarin Crimson
Area facing sky (cool)

Step 2

Burnt Sienna is rust colored, but it contains black so use Cadmium Orange in the direction facing the light instead. Immediately add Cadmium Red and Permanent Alizarin Crimson to represent the cooler area turned from the light. Work on dry paper, using enough water to permit the colors to blend freely. Allow the surface to dry. Wonder why we're adding red to the cool side of the pot? Look at your color wheel, and you'll see that red is cooler than orange.

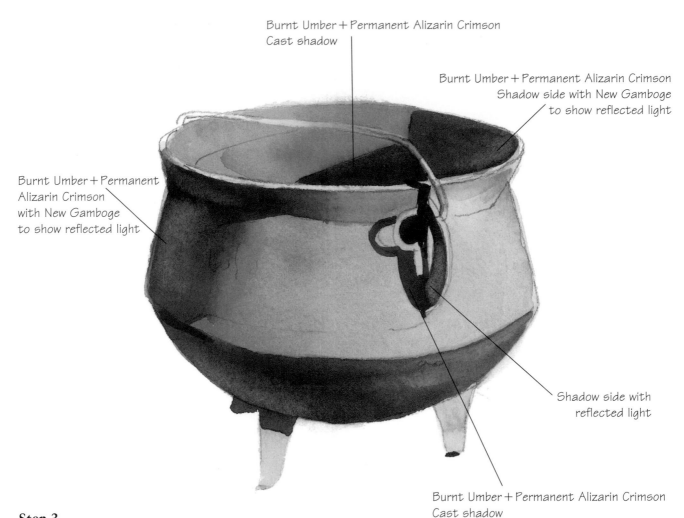

Burnt Umber + Permanent Alizarin Crimson
Cast shadow

Burnt Umber + Permanent Alizarin Crimson
Shadow side with New Gamboge
to show reflected light

Burnt Umber + Permanent
Alizarin Crimson
with New Gamboge
to show reflected light

Shadow side with
reflected light

Burnt Umber + Permanent Alizarin Crimson
Cast shadow

Step 3
Combine Permanent Alizarin Crimson and Burnt
Umber 40 percent darker than the sunlit side to
paint the shadow side. This mixture should be to-
ward red. Paint the shadow side with this mixture,
adding pure New Gamboge near the outer side for
the reflected light. Soften the edges to suggest the
rounded side. Dry.

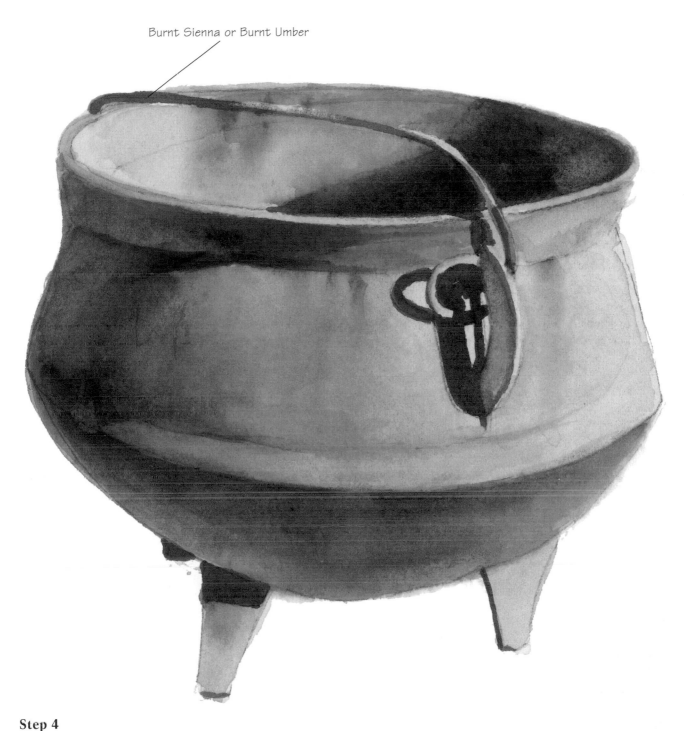

Burnt Sienna or Burnt Umber

Step 4

Now for the accents and detail. Dampen the side of the pot with clear water, and add a few spots of Burnt Sienna or Burnt Umber just under the flange near the top of the pot. Permit the color to run down the side. Repeat this process on the inside. Finally, complete the wire handle. Compare this pot with the one at the beginning of this project, and you can see how even dull surfaces can be made interesting.

Project 12: Paint the Illusion of Sunlight

Let's try another experiment painting the illusion of sunlight. This time we'll paint a white rose from a photograph taken in sunlight. The light penetrating the petals has made a warm glow in the center of the bloom, so we must deal with translucent light.

This project may appear more difficult, but take all the time you need. Remember, you are simply painting shapes. You may find it easiest to deal with one petal at a time.

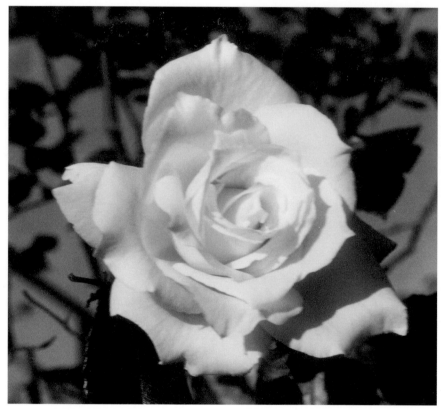

Notice that this reference photo of a white rose exhibits the same color temperature and value differences as you observed on the box on page 68.

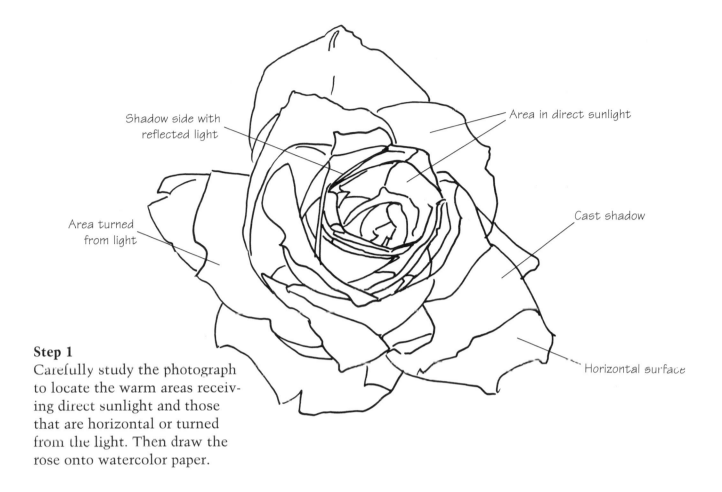

Shadow side with
reflected light

Area in direct sunlight

Area turned
from light

Cast shadow

Horizontal surface

Step 1
Carefully study the photograph
to locate the warm areas receiv-
ing direct sunlight and those
that are horizontal or turned
from the light. Then draw the
rose onto watercolor paper.

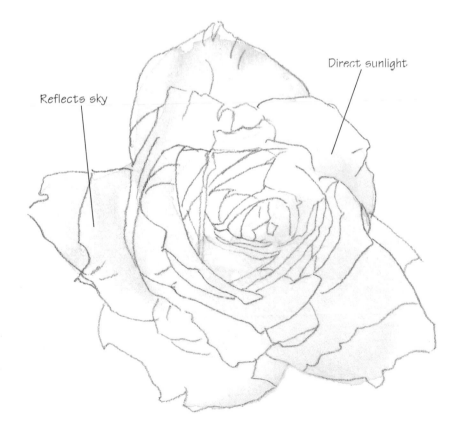

Reflects sky

Direct sunlight

Step 2
Use New Gamboge to add a glow
to the areas in sunlight and a
combination of Cobalt Blue,
Burnt Sienna and Rose Madder
Genuine for the cooler areas.

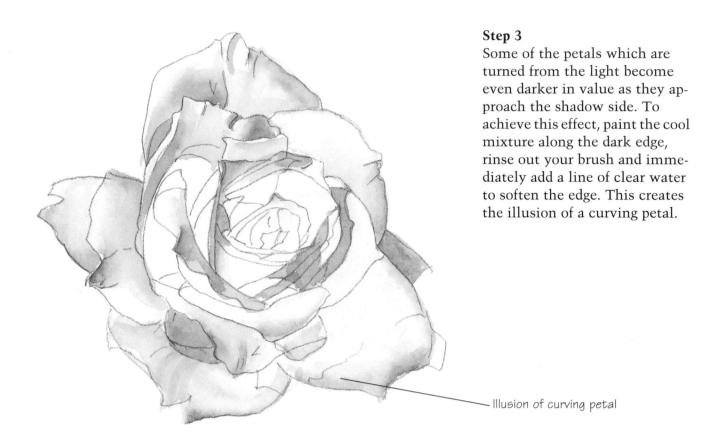

Step 3

Some of the petals which are turned from the light become even darker in value as they approach the shadow side. To achieve this effect, paint the cool mixture along the dark edge, rinse out your brush and immediately add a line of clear water to soften the edge. This creates the illusion of a curving petal.

——— Illusion of curving petal

Step 4

Refer to the photograph again to check for the warm translucent light areas. Add New Gamboge and Rose Madder Genuine to suggest these areas. Be sure to avoid the edges of the petals that are in direct sunlight.

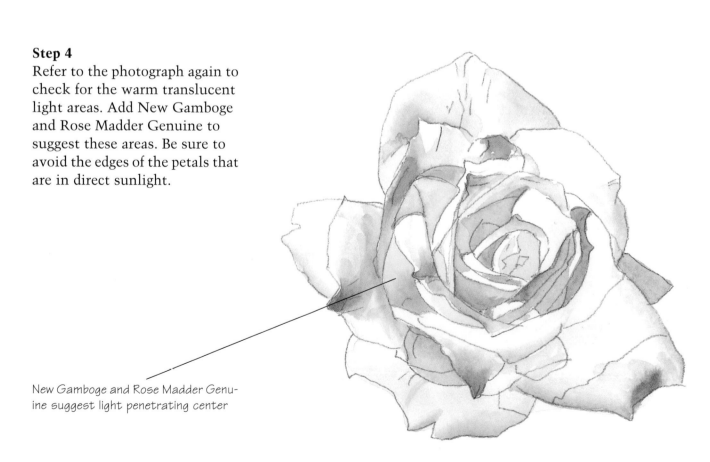

New Gamboge and Rose Madder Genuine suggest light penetrating center

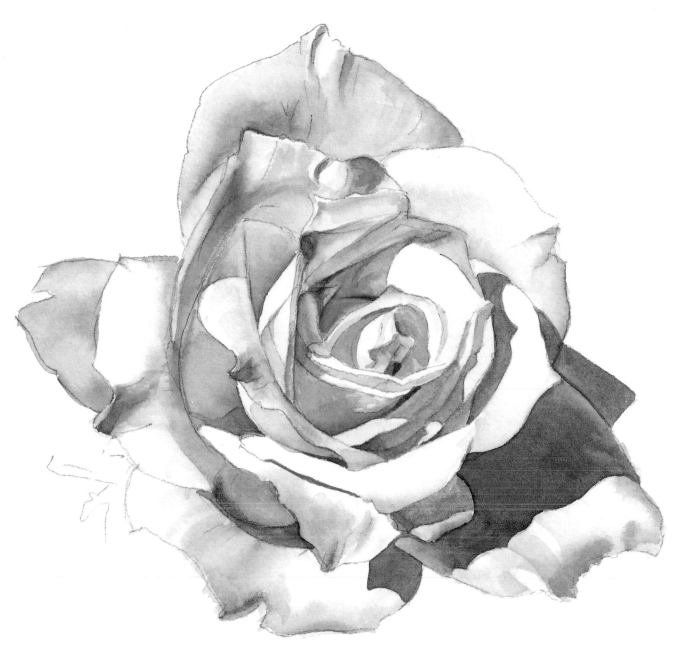

Step 5
Add the cast shadows and crevice darks. When
you've finished, study your work to see if you've
taken advantage of reflected light to add brilliance
to your painting.

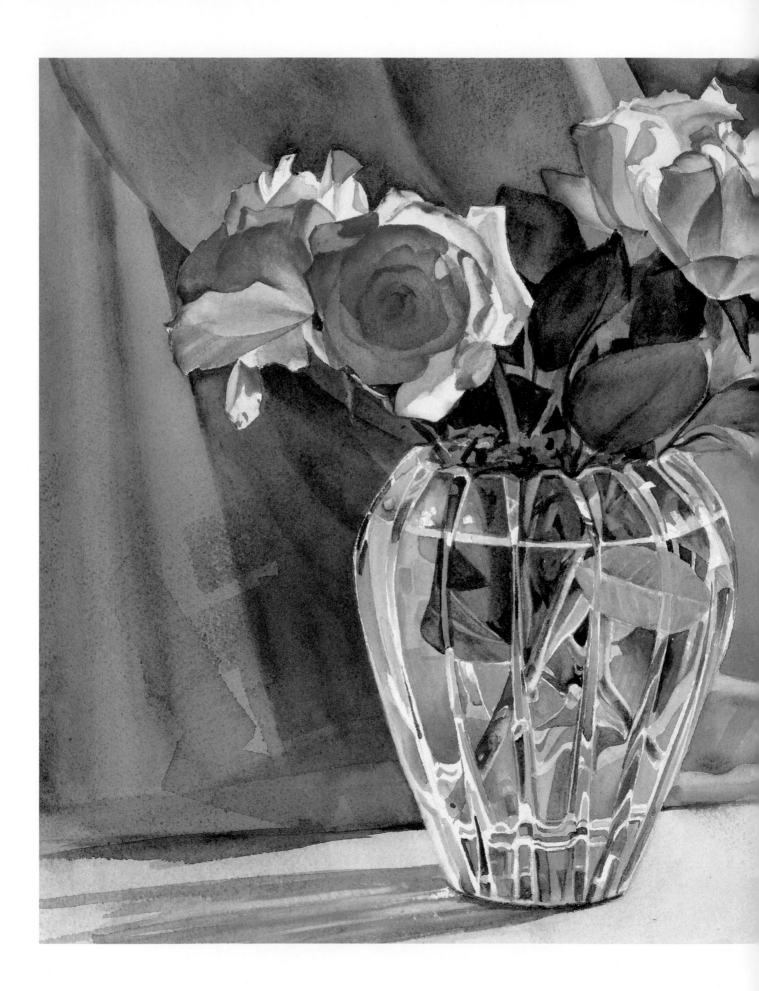

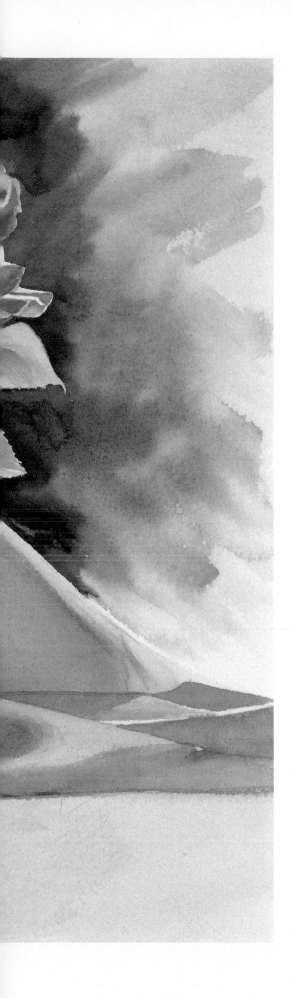

PUT IT ALL TOGETHER

Creative inspiration comes from the heart, but the actual process of painting boils down to painting shapes. The more you understand color and value the better choices you will make.

Now it's your turn to use what you've learned. At the end of each project in this chapter, you'll find a drawing similar to the one you just completed. Some of these exercises are simple, others may present a challenge; however, a scene that may *appear* complex doesn't necessarily mean it's difficult to paint.

Painting these demos in individual steps allowed me to stop and point out various colors and painting suggestions. Take your time and think about which color and value to use before you paint. When you finish one step, continue with the next until you have completed the whole project.

Four Roses
13½″×16″ (34.3cm×40.6cm)

Project 13: Use Liquid Frisket to Save Whites

Technically, white is a combination of all the colors in the spectrum. It has a very special place in most paintings. Years ago watercolorists considered the use of opaque white paint unacceptable. Today white paint is acceptable, much to the disgust of some purists, and casein and acrylic are rightly considered watermedia. They are welcomed in all but purists' shows.

Liquid Frisket

Another questionable practice is the use of liquid frisket to mask out areas that are to remain white. Liquid frisket is a substance with a consistency much like rubber cement. When applied to watercolor paper, it repels the paint. When the paper is thoroughly dry, frisket can be "lifted" with a rubber cement "pickup" or with an eraser, and the white paper beneath is rediscovered. Although this may sound good, there are disadvantages to liquid frisket:

- It leaves hard edges.
- It's difficult to apply smoothly.
- It can damage the paper.
- It can damage your brush.

For these reasons I seldom use liquid frisket, but now and then it's useful.

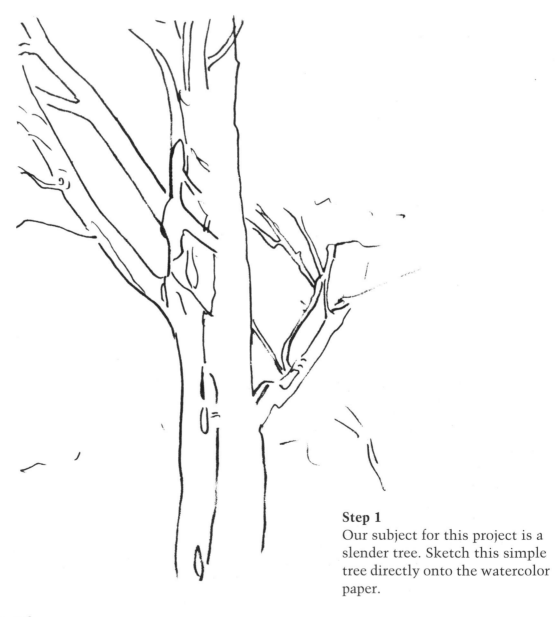

Step 1
Our subject for this project is a slender tree. Sketch this simple tree directly onto the watercolor paper.

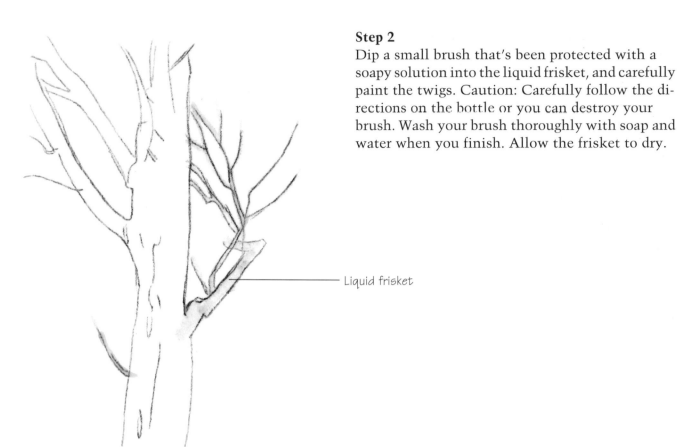

Liquid frisket

Step 2
Dip a small brush that's been protected with a soapy solution into the liquid frisket, and carefully paint the twigs. Caution: Carefully follow the directions on the bottle or you can destroy your brush. Wash your brush thoroughly with soap and water when you finish. Allow the frisket to dry.

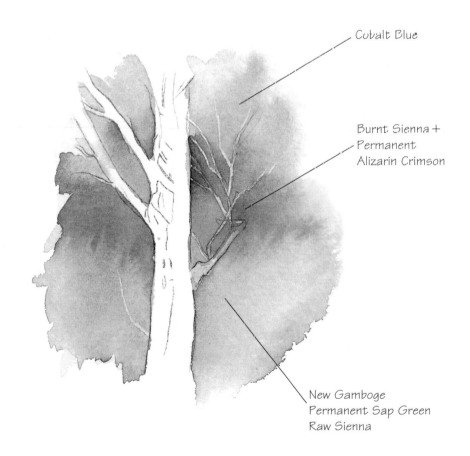

Cobalt Blue

Burnt Sienna +
Permanent
Alizarin Crimson

New Gamboge
Permanent Sap Green
Raw Sienna

Step 3
Wet the paper, avoiding the large branches and trunk of the tree. The frisket protects the twigs. In this wet surface, add Cobalt Blue near the top, followed by Burnt Sienna and Permanent Alizarin Crimson in darker values to suggest background bushes. Add New Gamboge, Raw Sienna and Permanent Sap Green in the foreground area. Dry thoroughly before you continue.

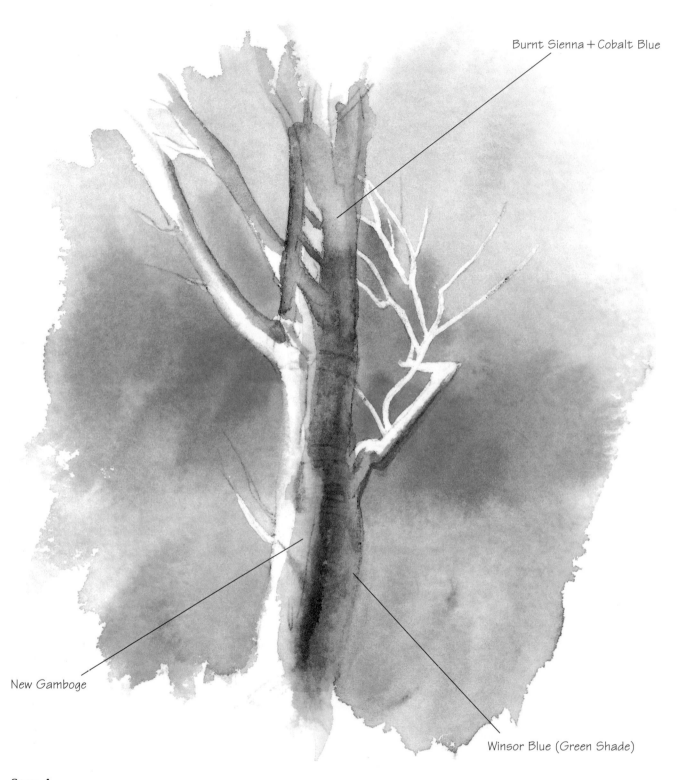

Burnt Sienna + Cobalt Blue

New Gamboge

Winsor Blue (Green Shade)

Step 4

Be sure the paper is dry and remove the frisket. A rubber cement pickup works best for this job. Caution: You can destroy your paper if you remove the frisket while the paper is damp.

Study the diagram and paint the trunk as you would a cylinder. Use pale New Gamboge be- tween the sunlit and shadow side. The core shadow is Burnt Sienna and Cobalt Blue. Use Winsor Blue (Green Shade) to suggest reflected light along the outside edge of the trunk. Before the paint is dry, use the end of your brush handle to score a few scratches in the bark.

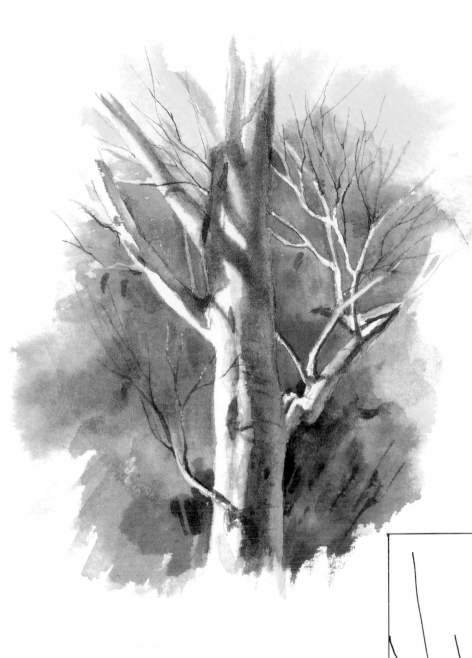

Step 5

Now it's time for darks and detail. Use a small brush or twig dipped in color to add to the length of the twigs left un-painted. Darken the foreground grass at the base of the tree and reinforce the background color where needed. Soften the edges of the large branches and tree trunk.

Here's another tree for you to paint using the same method. This time try adding the trees in the background while the paper is still damp. Use very little water on your brush so they'll hold their form but still have soft edges.

Project 14: Use a Limited Palette

One way to make sure a painting is harmonious
is to limit your palette to a few colors. In this
painting of a rural home in Oregon we'll use only
four colors: Winsor Blue (Green Shade), Permanent
Alizarin Crimson, New Gamboge and Burnt
Sienna.

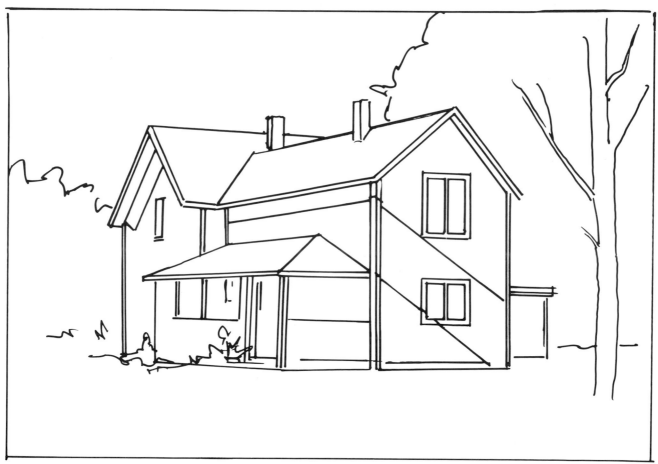

The shade side of the house in this sketch is so far turned
from the light that it's almost in shadow.

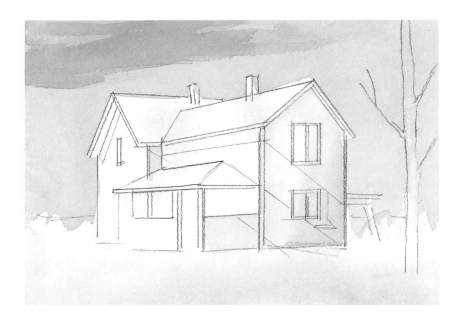

Step 1
Paint the shade side of the house and the sky with a pale wash of Winsor Blue (Green Shade). Next, paint the foreground with a passage of clear water beginning just beneath the house, adding Winsor Blue (Green Shade) as you approach the bottom of the page.

After the paper has dried, wet the face of the building and add a pale accent of New Gamboge near the shade side. Add the suggestion of a cloud with a mixture of Permanent Alizarin Crimson and Winsor Blue (Green Shade). Dry.

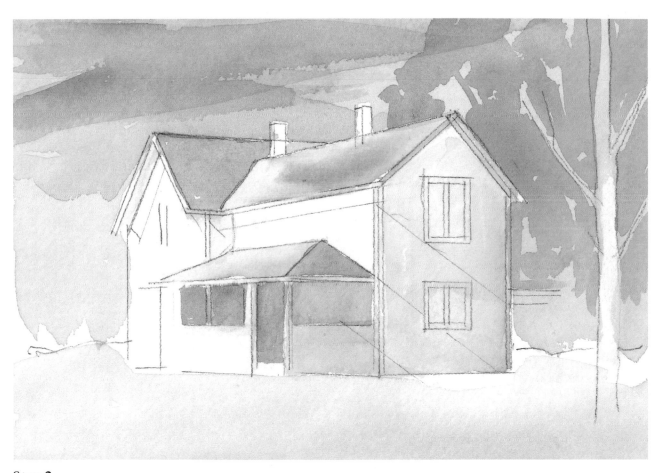

Step 2
Paint the interior of the porch using Winsor Blue (Green Shade), New Gamboge and Permanent Alizarin Crimson applied one at a time. Use New Gamboge with Burnt Sienna for the sunlit side of the roof and under the eaves on the shade side. Use Permanent Alizarin Crimson, Burnt Sienna and Winsor Blue (Green Shade) on the shadow side of the roof. Suggest a mass of trees in the background using a darker value of Winsor Blue (Green Shade). Be careful to avoid the tree in the foreground.

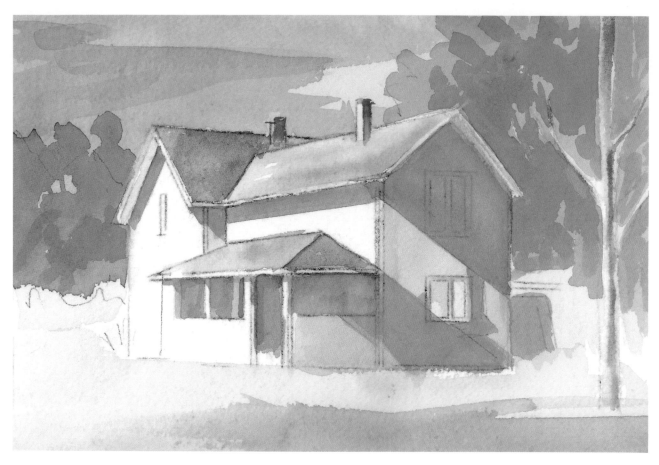

Step 3

Mix a middle value blue-gray using Burnt Sienna and Winsor Blue (Green Shade). With this mixture, paint the cast shadows and suggest a few more trees in the background. Dry.

Next, dampen the foreground tree with clear water, and paint a line of New Gamboge along the shadow side to suggest reflected light. Use Burnt Sienna to paint the shadow side. There's already water on the paper so you'll need very little water on your brush.

The sunlit side of the chimneys is New Gamboge plus a bit of Permanent Alizarin Crimson. Achieve the illusion of reflected light on the shadow side of the chimney by accenting the dark top with Permanent Alizarin Crimson and adding more yellow near the bottom.

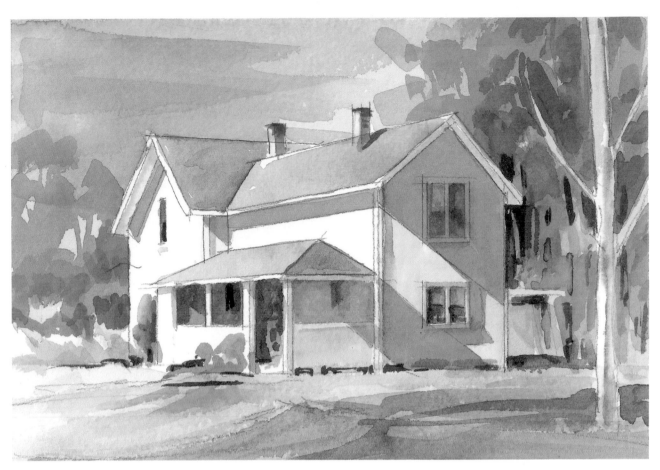

Step 4

Suggest the background forest with a dark mixture of Permanent Alizarin Crimson and Winsor Blue (Green Shade). Use the same colors to paint accents in the windows and the dark crawl spaces under the house. The sunlit bushes are New Gamboge and Winsor Blue (Green Shade).

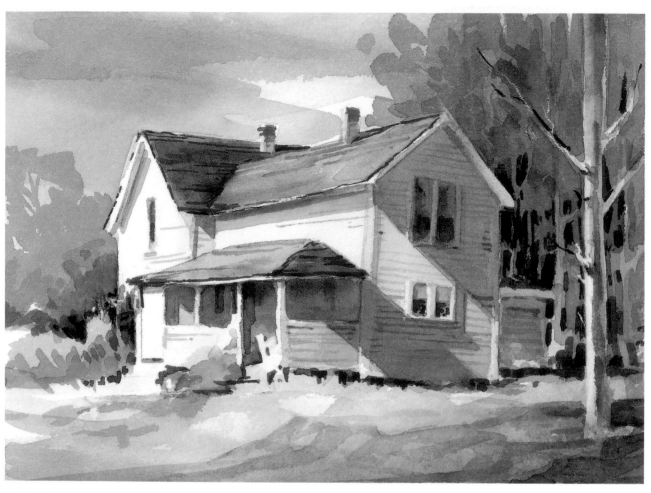

Step 5
Add final accents to the tree and foreground shapes to finish the painting. The shingles on the roof and the shadows cast by the chimneys are a dark mixture of Permanent Alizarin Crimson and Burnt Sienna. Use a few strokes of middle value blue-gray (Winsor Blue [Green Shade] and Burnt Sienna) to suggest the lines of siding.

Tip
Use a limited palette to ensure color harmony. A famous teacher once said, "With four colors, we are rich."

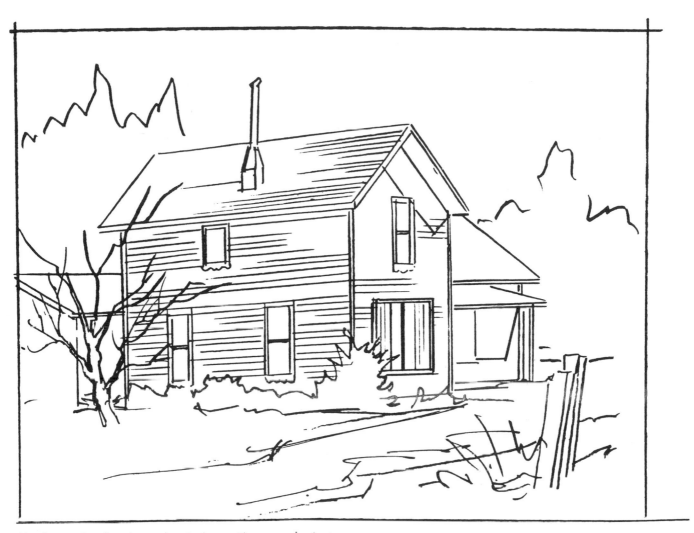

Here's another farmhouse located near the one we've just painted. The front of the house is in sunlight and the side is in full shadow. You can use the same palette as before or select one of your own. Be sure to maintain consistent value relationships throughout the painting.

Project 15: Use Color and Value to Paint a Face

Most people think of faces as either white, black, brown or yellow depending on ethnic heritage. As artists we must look more carefully. Apply what you've learned about color and value to any subject—including portraits.

I believe portraits are no more difficult than other subjects, but errors are so glaring we tend to avoid painting them. Nevertheless, most of us have someone we'd like to paint, so it's worth a try. Our young model for this project is Michael who lives in Albany, Oregon.

Since the human head is egg shaped, we can learn a great deal by studying the color on this simple shape. I've glued a paper nose and ears onto the egg to make it appear more human.

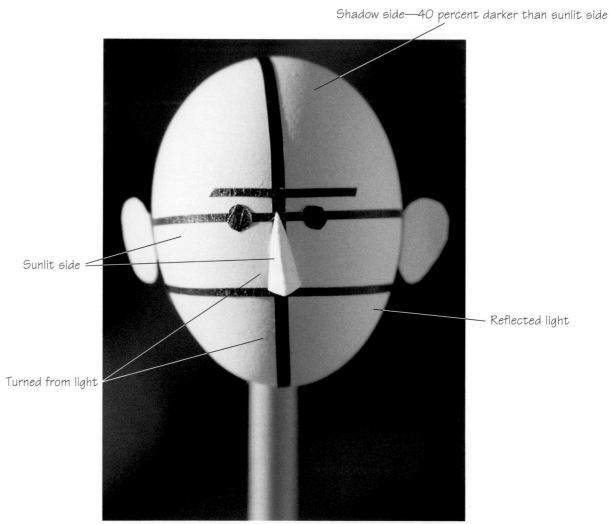

Shadow side—40 percent darker than sunlit side

Sunlit side

Reflected light

Turned from light

The front of the egg, which is slightly turned from the light, is cooler in color temperature than the sunlit side. The nose projects into the sunlit area. The shadow side of the egg is 40 percent darker than the sunlit side; and you can see reflected light along the outer edge. Notice the same distribution of color and value on Michael's face.

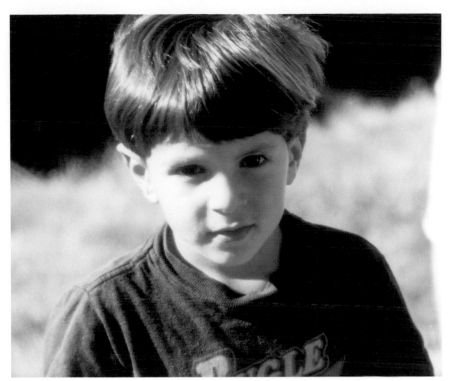

Reference photo

Step 1

Enlarge this drawing to about eight inches (20.3cm) high, and trace it onto watercolor paper. The lines inside the facial outline locate areas turned from the light. These shapes help model the face. You may not want to include them in your drawing, but it's important to notice they outline differences in color temperature and value.

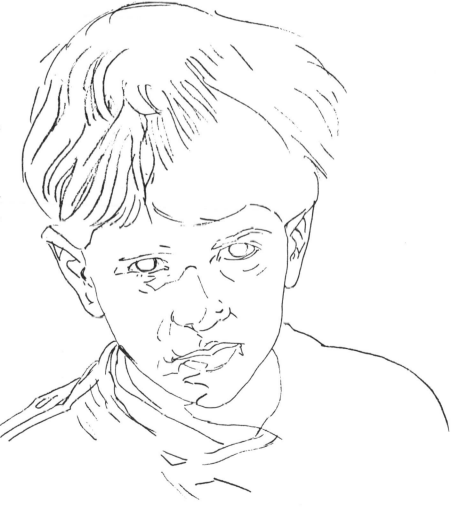

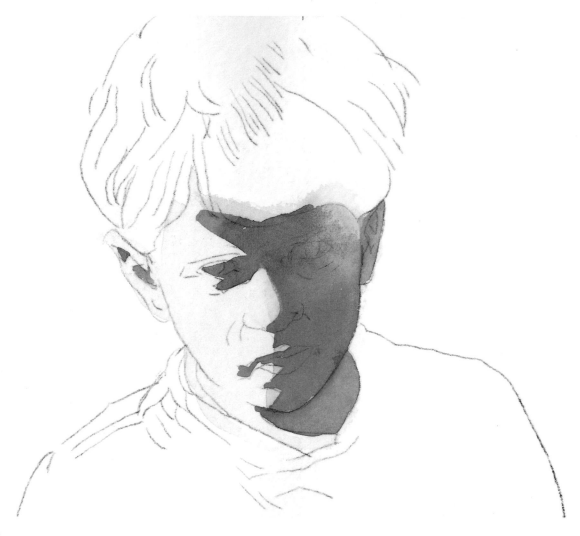

Step 2

Begin with Permanent Alizarin Crimson, and add New Gamboge a little at a time until you arrive at a warm skin color. Keep the value light. Paint the entire face, over the eyes and down the neck. Check for value when the passage has dried.

Prepare three new mixtures in your palette:

1. Permanent Alizarin Crimson and Burnt Sienna.
2. Permanent Alizarin Crimson and a small amount of Cobalt Blue.
3. New Gamboge slightly cooled with Winsor Green (Blue Shade).

Mixtures one and two should be toward red and 40 percent darker than the skin color you've painted.

Read these instructions through before you continue. In this step you'll paint the entire shadow side of his face, so you must know exactly where to put the color before you begin. Use a good quantity of water in your brush so you won't have to rush.

Paint the shadow side of the forehead with the cool red mixture, and add yellow-green near the temple to suggest reflected light. Immediately dip into the warm red mixture, and paint the rest of the shadow side of his cheek. Add the reflected light (New Gamboge) along the outside edge. Remember that reflected light is light, but the place where the sunlit area and shadow meet is where the 40-percent value difference occurs.

Finish by softening the edges on all rounded surfaces—but the important thing is to control the value. Good edges will come with practice.

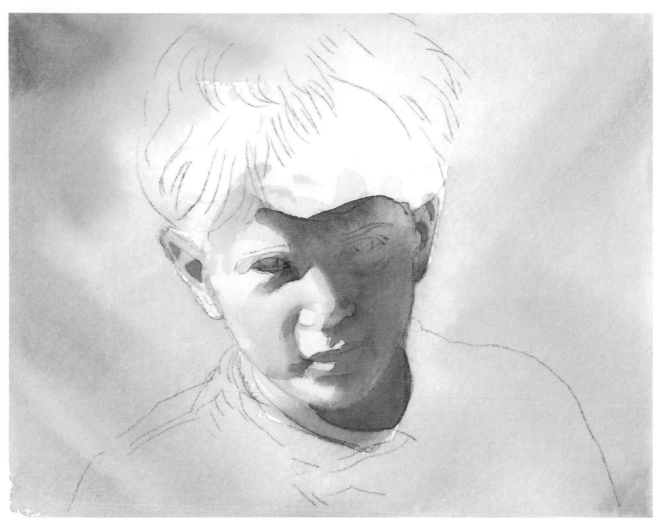

Step 3

To make his sunlit cheek appear rounded, paint a stroke of Cadmium Red along the outer edge followed immediately with a stroke of clear water. Let this dry, then repeat the process in the center of his cheek by first dampening the area. Then, starting in the outer corner of his mouth, bring the color in an inverted arc over to the outside edge of his cheek. Refer to the photograph and drawing often so you can see exactly where to place your brush.

Wet the background with clear water and float passages of Winsor Blue (Green Shade) and Permanent Alizarin Crimson over the shirt and into the hair while avoiding the face.

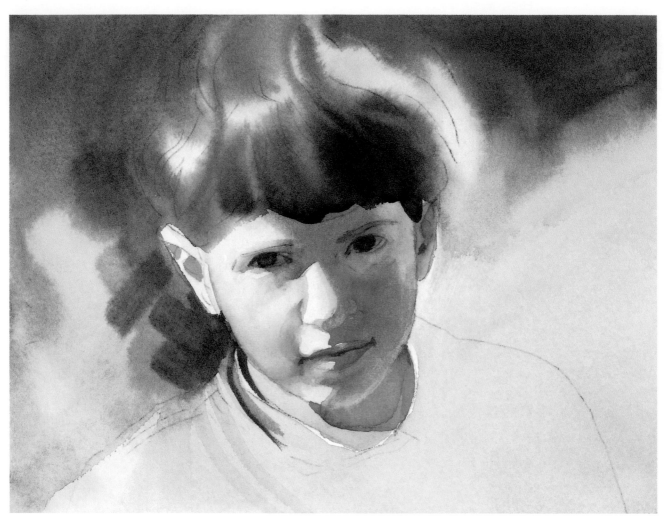

Step 4

Use the colors already on your palette to model the features on the shadow side. Look for shapes. Paint only what you see. There's a dark crevice (Permanent Alizarin Crimson and Burnt Umber) between his lips. You can use this same dark color to paint his eyes. Go slowly; remember, you are just painting shapes.

Use clear water to rewet the background and across the top of his head. With little water on your brush, paint his hair and out into the background with various strokes of Burnt Sienna, Permanent Alizarin Crimson and Winsor Blue (Green Shade).

Carefully paint around his cheek. Check to be sure you have the same 40-percent value difference between the sunlit and shadow side of his hair as in the rest of the portrait.

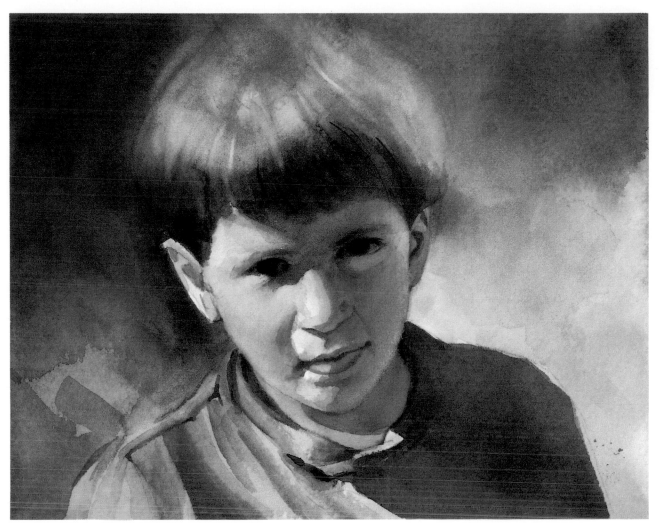

Step 5
Finish the portrait by adding color to the shirt and
making whatever corrections are needed.

Tip
Painting the hair and the
background at the same time
has more to do with tech-
nique than with color. Hair
should never appear rigid. By
letting the hair disappear
into the background, you
will avoid a pasted-on
appearance.

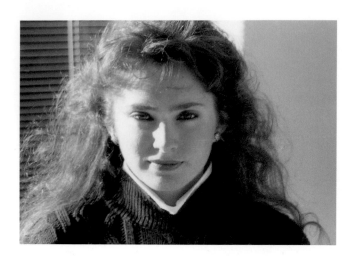

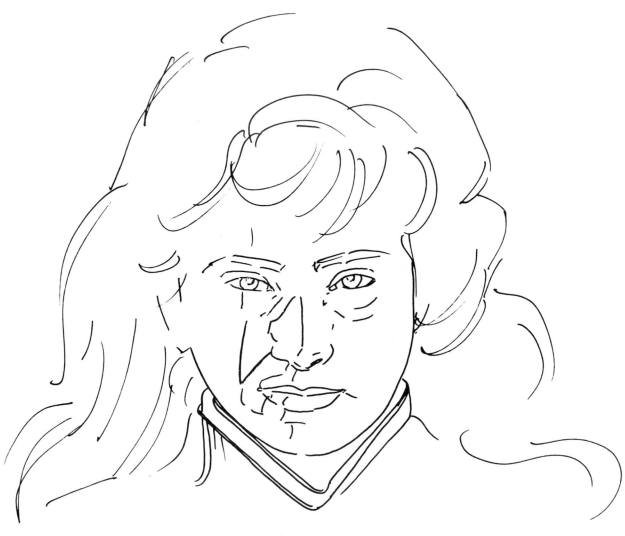

Here's a reference photo and a drawing for you to paint. Use the same colors we used in the last project or choose your own. Remember, reflected light is not always present. You may decide to omit it. Concentrate on good value relationships. As you learned earlier, value is the most important aspect of color.

Project 16: Reflections in Water

Measuring value helps us paint reflections in water successfully. It's best to begin with a still surface, such as a pond or a puddle. I found this boat high and almost dry in a marine repair yard. A recent rain supplied the mirrorlike puddle of water beneath.

Reflections have certain characteristics:
- The reflection mirrors the object exactly, only upside down.
- The color in the reflection is less intense.
- There are no hard edges in a reflection.
- The reflection is one value darker than the object.

This value difference holds true for values 1 through 7; however, the sky pours so much light onto the water that reflections will not get darker than value 7. Therefore, the reflection of very dark objects should be painted value 7.

Even if this project appears daunting, you'll find the painting process logical and easier than you may anticipate.

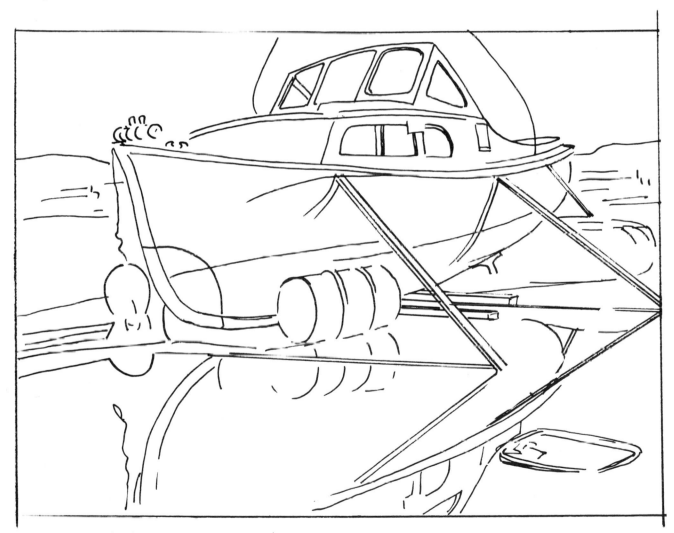

Begin by tracing the drawing onto your watercolor paper. Take your time and be as accurate as you can. A good drawing makes painting easier.

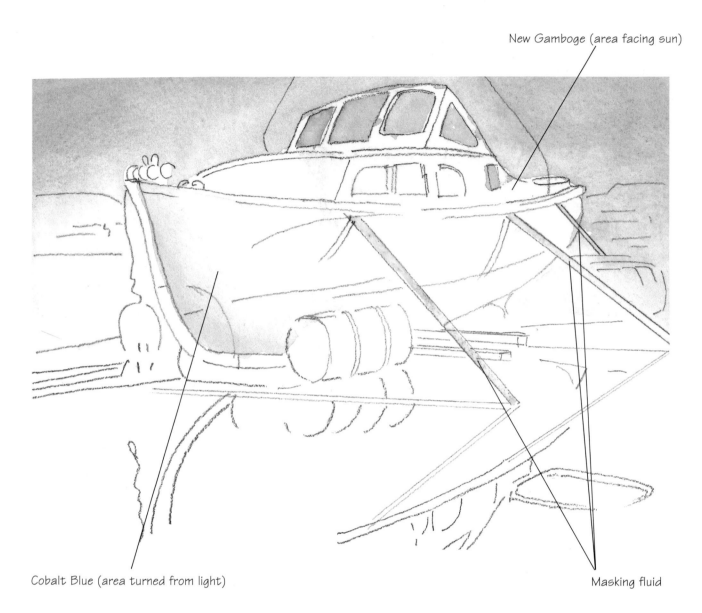

New Gamboge (area facing sun)

Cobalt Blue (area turned from light)

Masking fluid

Step 1

You'll need to either mask or paint around the
boards supporting the side of the boat. To mask
these boards use masking fluid or clear tape cut to
the appropriate size. Since the boards are narrow,
masking fluid is probably the best choice. Once
the masking is accomplished, paint a pale tint of
New Gamboge along the edge of the hull in direct
sunlight, then use Cobalt Blue to paint the forward
part of the hull where it's turned from the light.
The sky is Cobalt Blue with a passage of Rose Mad-
der Genuine brushed in while the paper is still
damp.

Winsor Blue (Green Shade) + Burnt Sienna

Shadow side with reflected light

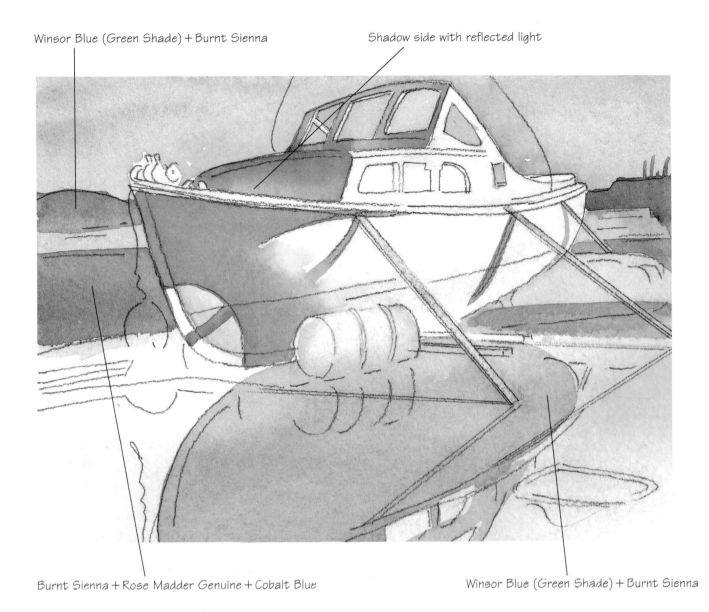

Burnt Sienna + Rose Madder Genuine + Cobalt Blue

Winsor Blue (Green Shade) + Burnt Sienna

Step 2

Use Winsor Blue (Green Shade) that's been grayed with a touch of Raw Umber (value 4 +) to paint the shadow side of the boat. Charge in New Gamboge to suggest reflected light.

The reflection of the boat on the water should be one value darker than the boat itself. Use a neutral gray made by combining Winsor Blue (Green Shade) and Burnt Sienna. Darken the mixture to paint the background hills. The ground behind the boat is warm gray—a mixture of Burnt Sienna, Rose Madder Genuine and Cobalt Blue.

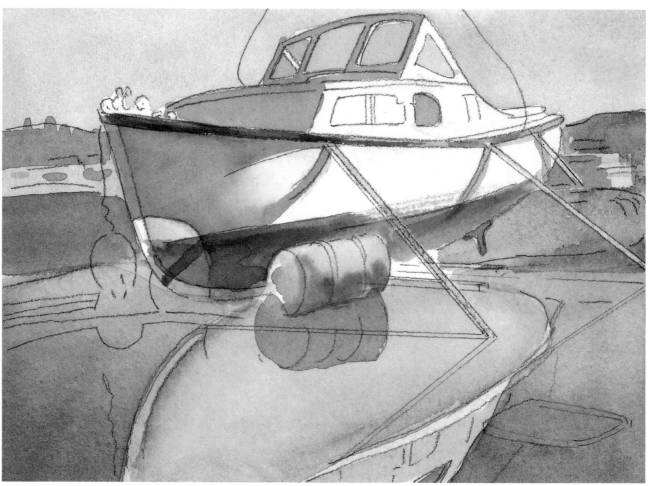

Step 3

To paint the water around the reflection of the boat's hull, begin with Cobalt Blue near the bottom of the boat. Darken the value, adding Rose Madder Genuine as you approach the bottom of the paper.

The drum is painted in the same way as the rusty pot on pages 72-75. Use New Gamboge, Cadmium Orange, Burnt Sienna and Permanent Alizarin Crimson. The drum's reflection is a warm gray made by mixing Burnt Sienna and Cobalt Blue. Use a mixture of Permanent Alizarin Crimson and Burnt Sienna to suggest the red paint on the bottom hull.

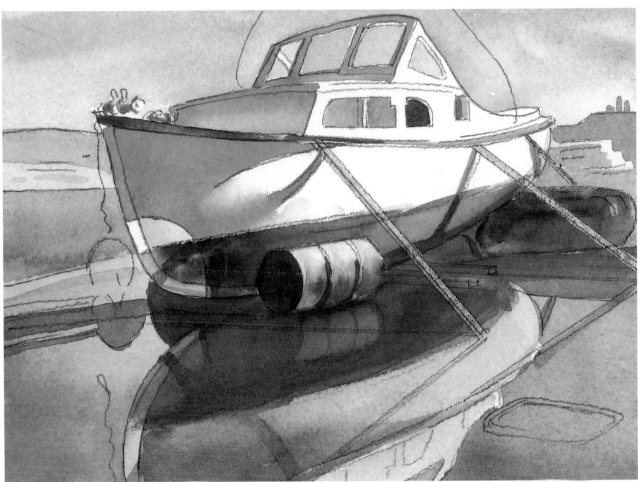

Step 4

Add Cobalt Blue to the Permanent Alizarin Crimson and Burnt Sienna mixture. Paint the reflection of the hull, avoiding the reflection of the drum with this mixture. Let the area dry, and add another wash of the same color over the entire area, including the drum. Before this dries, use a brush loaded with Burnt Umber and a little water to suggest the end of the drum and the round bands. Be careful to keep the value no darker than 7.

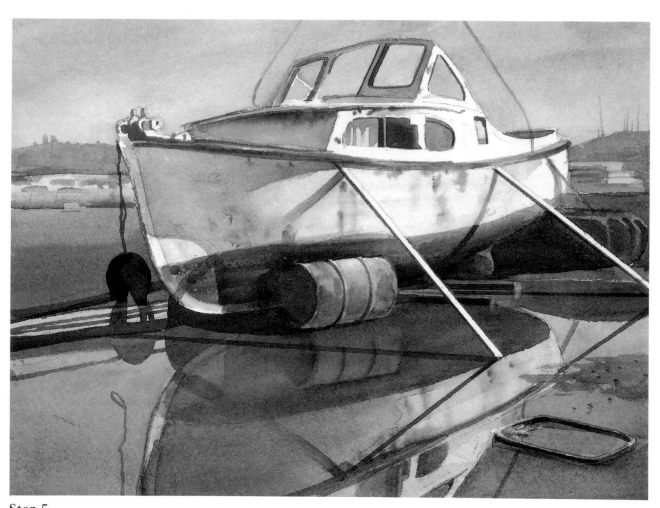

Step 5
Use Burnt Sienna and Permanent Alizarin Crimson to paint the shadows cast by the boards supporting the hull and the drum. To suggest rust running down the hull, wet the paper and dab a spot of Burnt Sienna onto the surface. Tip the paper to permit the color to run down the page. Use a soft brush and clear water to soften any hard edges in the reflections. Remove the liquid frisket or tape, and paint the shadow side of the boards.

Tip
Take time to study puddles of water. Puddles that appear lighter than the surrounding area seem to have dark edges, but the edges of dark puddles often sparkle with light.

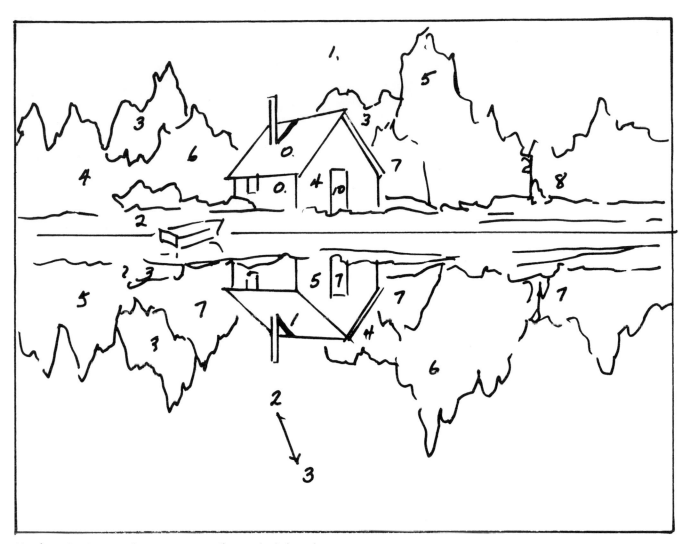

Here's a simple scene for you to paint. I've marked the values to help you get started. Reflective surfaces can make even simple scenes appear interesting.

Project 17: Paint Dark Values

Painting very dark objects can be troublesome. Carelessness can cause dark colors to go flat. To avoid this, artists typically raise the value and brighten the intensity of the sunlit side of the object.

Our subject here is a dark red rose. (In case you're wondering why paint another rose, I could think of no other dark object that offers so interesting a challenge.) The petals of the rose here are red on one side and white on the other. I've sketched it at a slightly different angle so we can compare the value differences of the white and red surfaces in shadow.

Reference photo

Sketch of rose

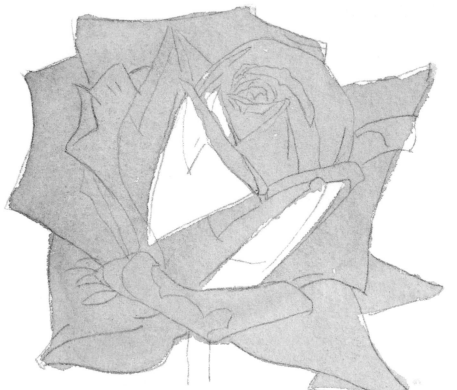

Step 1

Paint all but the white areas of the rose with a wash of Rose Madder Genuine. While wet, dash in Cadmium Orange in the direction of the light. Dry.

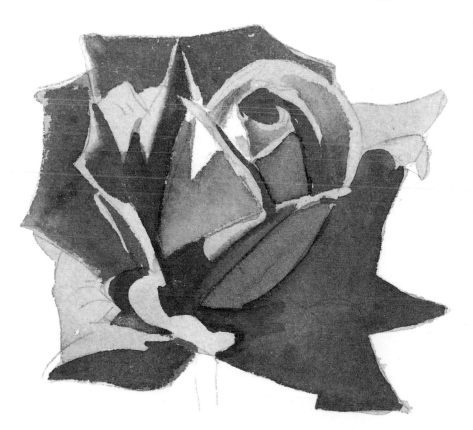

Step 2

Paint the white parts of the petals that are in shadow with a mixture of Cobalt Blue and Burnt Sienna, value 4+. Next paint the shadows on the red petals with a mixture of Burnt Sienna and Permanent Alizarin Crimson. Go slowly, and study the location of each shape as you paint.

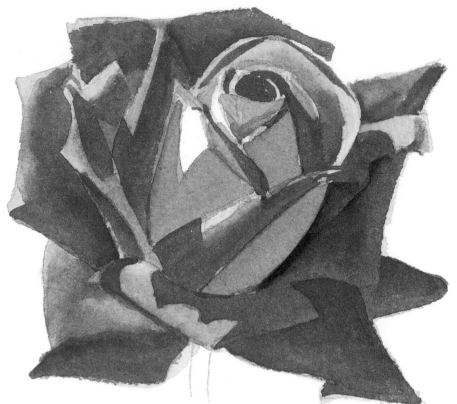

Step 3
Use darker values of the Permanent Alizarin Crimson and Burnt Sienna mixture to darken the petals near the center of the bloom.

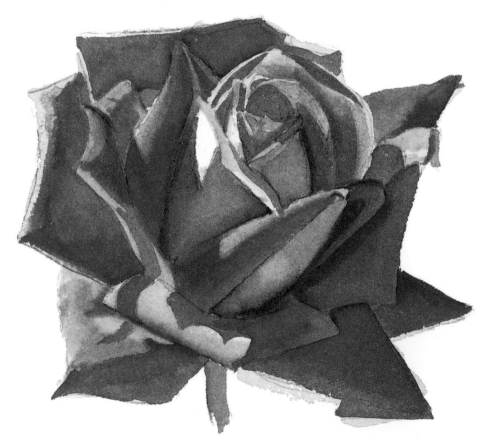

Step 4
Use dark wedge-shaped accents of color (Burnt Umber and Permanent Alizarin Crimson) near the base of the petals and where they overlap. A rosy glow penetrates the petals on the left and reddens the cast shadow across the white inner bud.

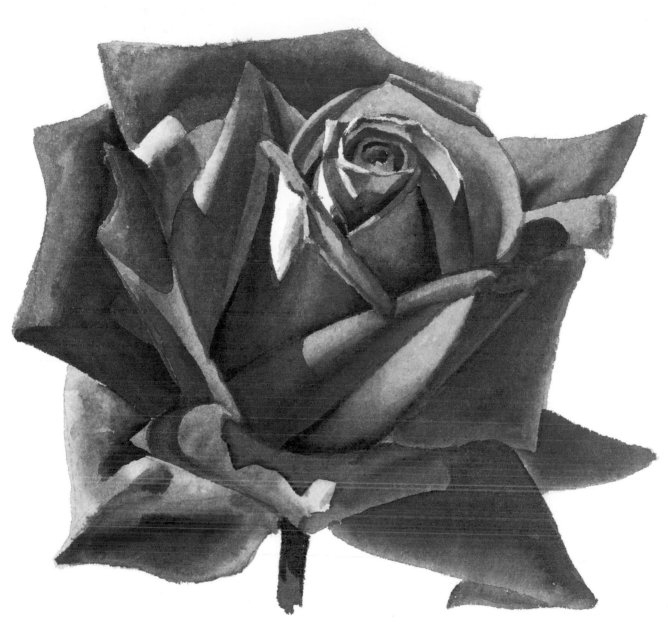

Step 5

Mix a dark red-violet using Permanent Alizarin Crimson and French Ultramarine Blue. With a small brush use the mixture to complete the detail at the rose's center.

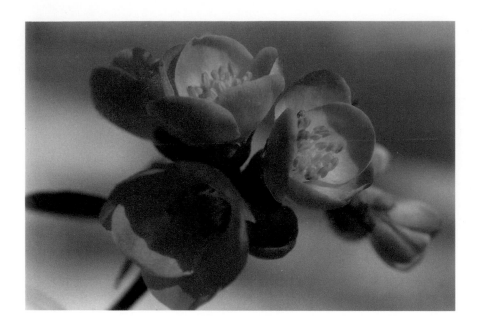

Now it's your turn. You can use the same colors we used in this project to paint the red quince pictured here.

Project 18: Paint Leaves in Sunlight

Leaves can be as interesting and lovely as flower blossoms and should be painted as carefully. Even though many leaves appear similar in shape and size, every plant has leaves uniquely their own.

I took this photo of salal leaves in our backyard. The slightly serrated edges are similar to edges on rose leaves, but not as pronounced. The leaves become stiff as they mature, and the color deepens from pale yellow-green to deep, rich green. The stems are reddish in hue and break at sharp angles with each leaf.

Most of the leaves in this photo are slightly turned from the light and are somewhat cooler in color temperature than those in direct sunlight. The cast shadows are a full 40 percent darker than the sunlit side, but there's a few places where the cast shadow has been affected by sunlight penetrating a nearby leaf. The veins of each leaf are visible and light in value.

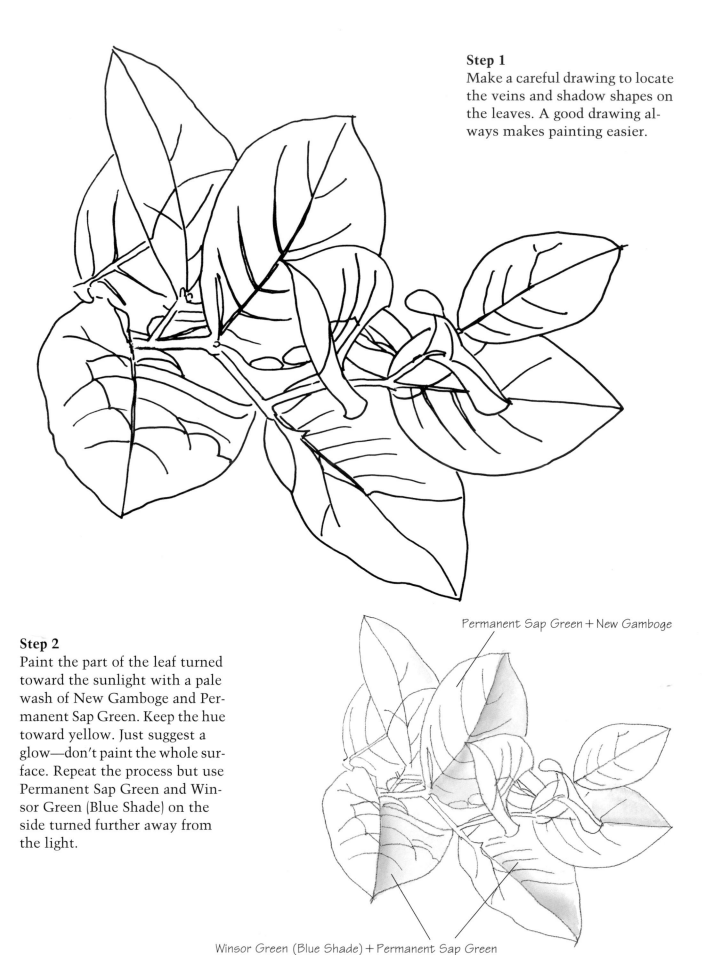

Step 1
Make a careful drawing to locate the veins and shadow shapes on the leaves. A good drawing always makes painting easier.

Permanent Sap Green + New Gamboge

Step 2
Paint the part of the leaf turned toward the sunlight with a pale wash of New Gamboge and Permanent Sap Green. Keep the hue toward yellow. Just suggest a glow—don't paint the whole surface. Repeat the process but use Permanent Sap Green and Winsor Green (Blue Shade) on the side turned further away from the light.

Winsor Green (Blue Shade) + Permanent Sap Green

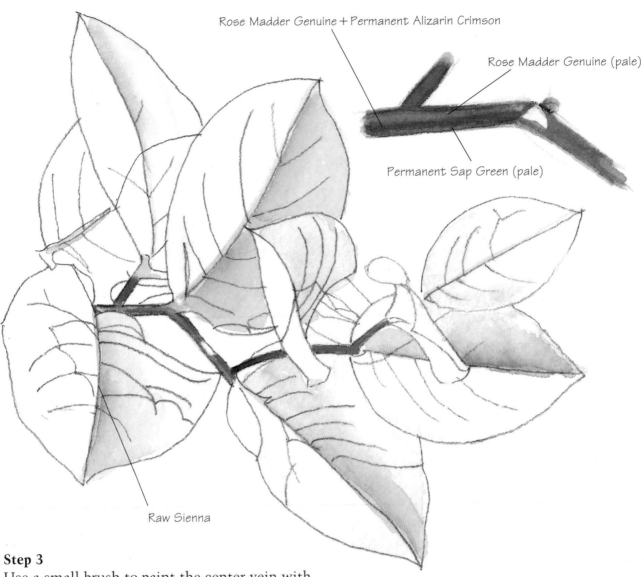

Rose Madder Genuine + Permanent Alizarin Crimson

Rose Madder Genuine (pale)

Permanent Sap Green (pale)

Raw Sienna

Step 3

Use a small brush to paint the center vein with Raw Sienna. Painting the veins first will help to avoid them when you paint the surface of the leaves. Use Permanent Sap Green along the bottom edge of the stem and immediately add Rose Madder Genuine. Before this dries, add a darker swatch of Rose Madder Genuine and Permanent Alizarin Crimson immediately above the green.

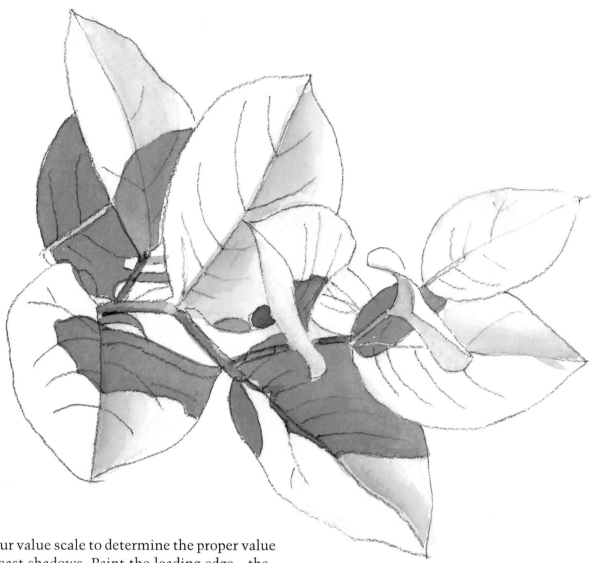

Step 4

Use your value scale to determine the proper value
of the cast shadows. Paint the leading edge—the
part where the sunlit and shadow areas meet—
with a cool green. Add a warmer green hue in the
center. Use Winsor Green (Blue Shade) followed
immediately with Permanent Sap Green in the
center of the shadow shape. There's a great deal of
light penetrating the small leaf on the right, warm-
ing the color temperature of the cast shadow on
the leaf below. Warm this cast shadow by adding
a bit of New Gamboge to the darker mixture.

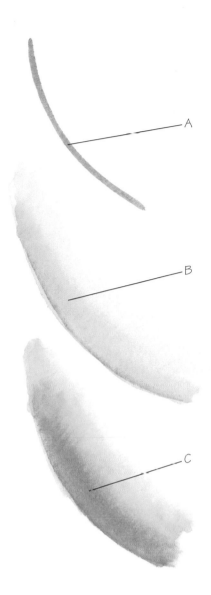

Step 5

The veins branch from the center creating a series of gentle curves across the surface of each leaf. Paint each curve independently to create this illusion. Have a good amount of water in your brush, and paint a line of Permanent Sap Green following the contour of the surface (A). Before the surface has dried, wash your brush and paint a stroke of clear water right above the original one (B). Now, use less water and more intense color and paint a darker passage halfway between the soft and hard edges (C). Notice that the surface appears to dip toward the dark edge. Use the same method to paint the entire leaf. Only the hue and value changes (D).

If it's easier, you can move the paper around to get the right angle for these curves. It's a good idea to practice this stroke a few times before you begin painting the leaves.

Step 6

After painting the leaves, use the dark background colors to suggest serrated edges. Paint little notches onto the edges of each leaf as you paint around them. Use various mixtures of Permanent Alizarin Crimson and Burnt Umber, Winsor Blue (Green Shade), Winsor Green (Blue Shade) and Burnt Sienna. Apply these colors one at a time, and let them blend on the paper.

If the background appears too dominant, allow the painting to dry thoroughly and paint a light wash of Cobalt Blue over the entire background. Cobalt Blue is a high-intensity, opaque color, so the little grains of pigment form a slight haze to soften the background color.

I've completed part of the leaves and leave the rest to you.

Project 19: Use Glazes to Paint a Watercolor

The process of painting one color over another is called *glazing*. Glazing enables you to create a depth of color that is difficult to obtain in other ways. In chapter one you learned that some watercolor pigments penetrate the paper and resist lifting. These are called *dyes*. Opaque pigments lie on the surface. Knowing this information helps you make better choices whenever you want to paint one color over another.

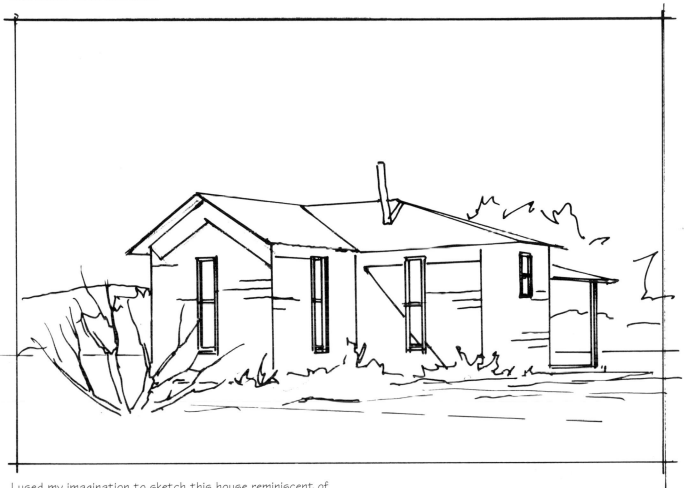

I used my imagination to sketch this house reminiscent of those old whitewashed adobe dwellings you might find in remote desert areas.

Step 1

We'll use several big washes in this project, so I suggest you begin on a piece of stretched water-color paper. Draw or trace the sketch on page 117. Wet the entire sky area with clear water, then float in New Gamboge, darkening the value near the right side.

Leave the paper white on the part of the house in direct sunlight. Add a few pale strokes of Cadmium Orange near the shadow side. Suggest the underlying adobe bricks with darker strokes of Cadmium Orange. Also paint the sun glancing off the rusty tin roof and the dull orange ground with Cadmium Orange. Use Winsor Blue (Green Shade) for the path and the side of the roof turned from direct sunlight. Dry.

Step 2

Rewet the sky area, and float in a light wash of Permanent Alizarin Crimson over the entire surface, including the background hill and trees. Paint the cast shadows and the shadow side of the house with New Gamboge, taking care to avoid the windows. Dry.

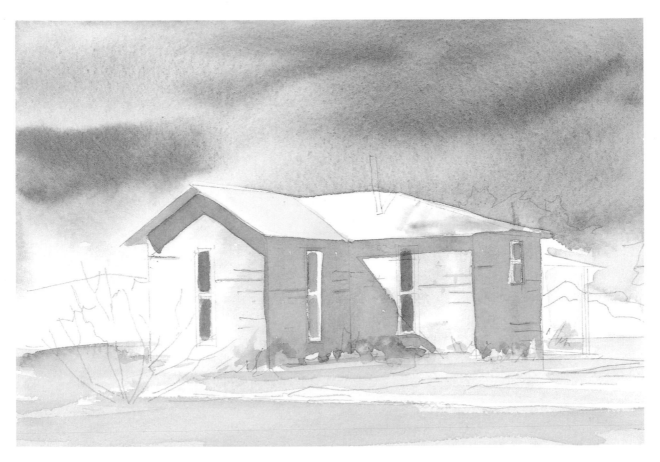

Step 3

Rewet the sky a third time and paint the blue-gray clouds with a mixture of Winsor Blue (Green Shade) and Rose Madder Genuine. Neither of these pigments contain black, so the clouds will glow with light.

Glaze a light wash of Permanent Alizarin Crimson over the yellow shadow shapes on the building and over the ground to cool its surface and make it appear flat.

Suggest a few bushes near the base of the house with a mixture of Permanent Sap Green and New Gamboge. Use Winsor Blue (Green Shade) for the windows. Dry.

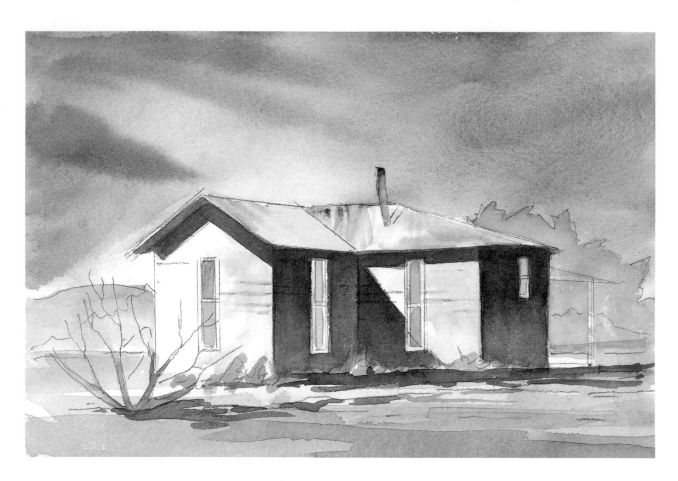

Step 4

Use a mixture of Winsor Blue (Green Shade) and Rose Madder Genuine, and paint the final glaze over the cast shadows under the eaves and across the front of the building. Let the pigment dry and use the same colors to paint the shadow sides. This time, while the pigment is wet, wash out your brush and remove most of the water from it. Use the brush to pick up pigment near the base of the wall. This permits the underpainting to show through, suggesting reflected light.

Glaze the windows in direct sunlight with Cadmium Orange to suggest a dust-covered surface.

Use your value scale as you progress to ensure consistent value relationships across the entire picture area.

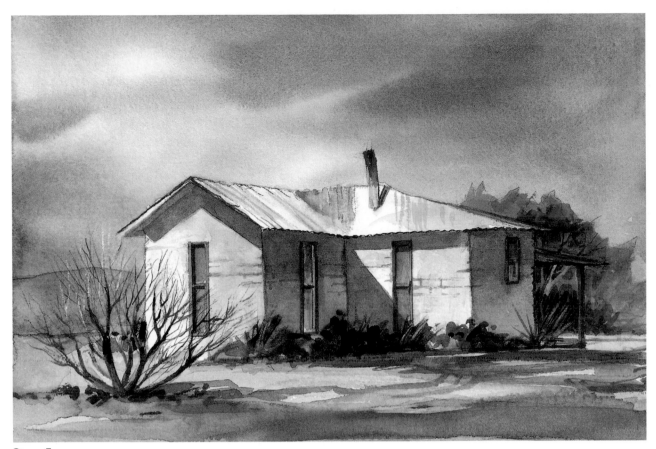

Step 5

Rewet the sky on the left side of the house, and add more of the Winsor Blue (Green Shade) and Rose Madder Genuine mixture over the background hill and along the edge of the house. This accentuates the white wall and makes the hill appear farther in the distance. Use a mixture of Permanent Sap Green and Winsor Blue (Green Shade) for the green bushes in shadow.

Use Burnt Sienna to paint the window sills and the ragged bush in front of the house. Use the same color to paint the stovepipe, and add detail to the rusty corrugated tin roof. Finish the tree in the background by adding darker branches and detail.

Project 20: Manipulate Values to Create Negative Shapes

You were introduced to *negative painting* in Project 18 (page 111) when you painted around the leaves with dark colors. In watercolor, negative painting means you paint a dark area in order to reveal a lighter one.

Step 1
You'll need a piece of good watercolor paper at least twelve inches (30.5cm) square for this project. We won't be drawing—the pigment will do the drawing for us. Begin with a wash. You can either thoroughly wet the paper and charge in colors (wet into wet), or you can add colors to dry paper one at a time, allowing them to blend on the paper. Keep the value as uniform as possible. Dry.

Step 2
The magic begins when the wash dries. Study where the colors have blended or where the pigment is thicker; look for what could be a leaf or a stem.

Step 3
Once you find a shape, bring it into focus by painting around it with a darker value of the same hue.

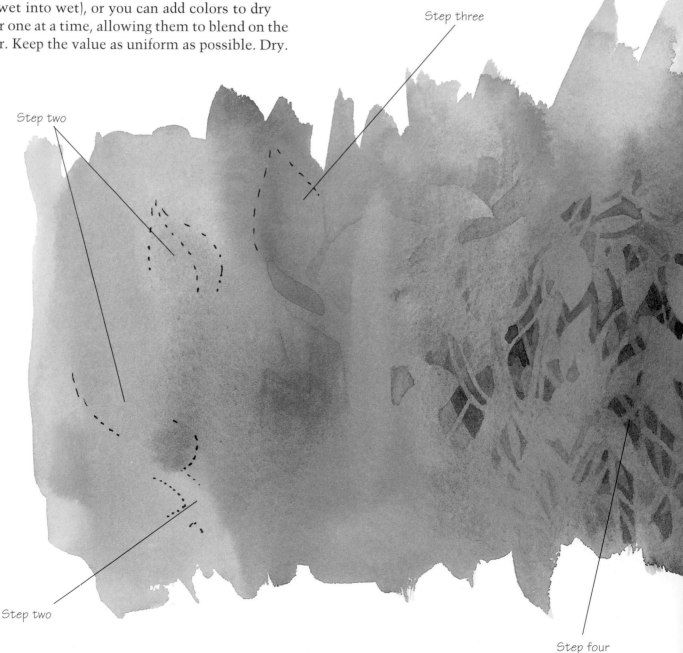

Step three

Step two

Step two

Step four

Step 4
Continue in this manner and find several shapes across the page.

Step 5
Look for new shapes in and around the darker shapes you've just painted. Add new stems or leaves with an even darker value. These shapes appear behind the ones you first painted.

Step 6
Let the paper dry again, and continue finding new shapes and painting them with still darker values until you've created a jungle of ever-receding shapes. Use crevice darks (Permanent Alizarin Crimson and Burnt Umber) for the innermost places.

It's easy to see that ever darker values make shapes appear to recede further into the background. This kind of negative painting takes imagination, but that's what makes it so fun!

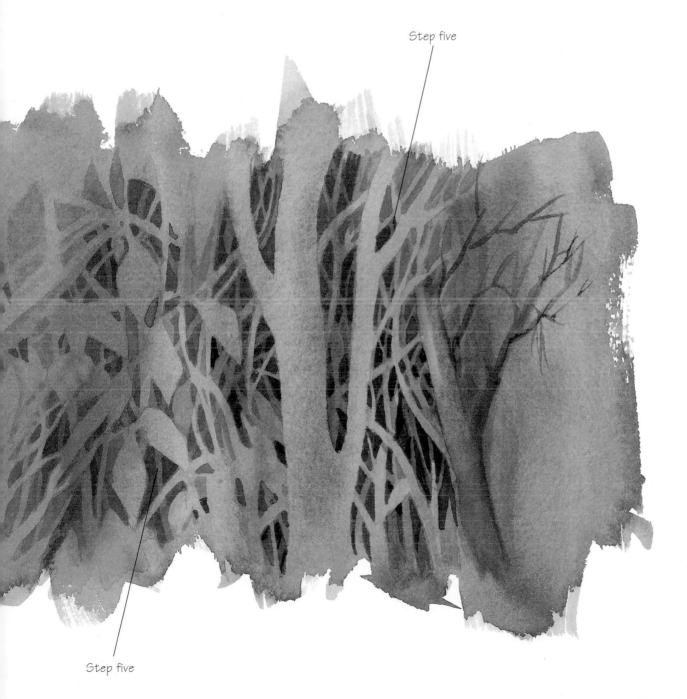

Step five

Step five

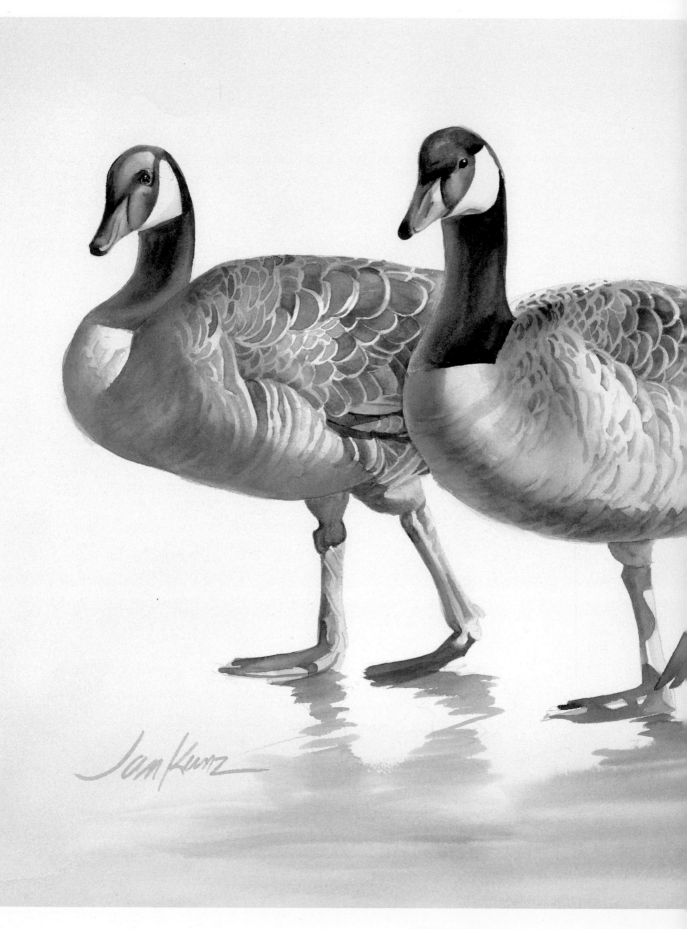